GILLINGHAM

& AROUND

From Old Photographs

BRIAN JOYCE & SOPHIE MILLER

AMBERLEY

Acknowledgements

We would like to acknowledge the invaluable help given to us by the staff of Medway Archives and Local Studies Centre (MALSC). They include Alison Cable, Catharina Clement, Norma Crowe, Irina Fridman, Cindy O'Halloran, Nikki Pratt, Alison Thomas and Helen Worthy. Also, we would like to extend our special thanks to Vic Chidley, Betty Ellis, Philip MacDougall and Kevin and Nicola Mapley for kindly lending us photographs from their own collections. Every effort has been made to identify the copyright holders of the images in this book. The authors apologise for any accidental oversight.

First published 2014

Amberley Publishing
The Hill, Stroud
Gloucestershire, GL5 4EP

www.amberley-books.com

British Library Cataloguing in Publication Data.
A catalogue record for this book is available from the British Library.

ISBN 978 1 4456 3297 1 (print)
ISBN 978 1 4456 3306 0 (ebook)

Typesetting and Origination by Amberley Publishing.
Printed in the UK.

Introduction

The history of Gillingham is really the story of several communities that developed within the same ancient parish. The medieval village of Gillingham grew up on high ground above the River Medway. Its people lived by farming and fishing. The place remained a quiet backwater for centuries, despite the presence of the neighbouring Royal Naval Dockyard at Chatham.

However, from the late seventeenth century, the yard expanded, resulting in the creation of the township of Brompton within Gillingham parish. This community, which straddled the boundary with Chatham, was a melting pot of dockyard workmen, better-off dockyard officials and military and naval officers.

But the real transformation of the parish took place in the nineteenth century with the rapid growth of Chatham Dockyard. The new township of New Brompton mushroomed within the parish of Gillingham to satisfy the demand for housing. When the dockyard's Victorian extension began in the 1860s, skilled workers from all over the United Kingdom flocked to the area for jobs in the yard. Landowners sold farmland to speculative builders who constructed acres of housing for the new arrivals, particularly northwards in the area between the High Street and the River Medway.

In time, the town of New Brompton spread southwards too, again on former agricultural land such as Westcourt Farm. At one time, it was one of the fastest growing towns in the country.

Chapels and missions of various denominations proliferated, indicating the diverse origins of this community. For example, the Church of Scotland had a place of worship in Paget Street. There were also Orange Lodges, betraying the Ulster and Western Scottish origins of many of its inhabitants. So many residents hailed from Great Yarmouth that they formed their own Friendly Society. This heterogeneous population had one thing in common – most families were headed by skilled dockyard workmen. Because most of these people came from the respectable working class, New Brompton avoided most of the social problems that plagued Chatham.

When New Brompton was granted borough status in 1903, it chose to call itself Gillingham after its parent parish. Its football club and railway station were eventually renamed accordingly. The twentieth century also saw boundary

changes, which led to the Chatham portion of Brompton being absorbed into Gillingham.

In time Gillingham developed further. The presence of chalk and river mud in the area encouraged cement and brick making to spread along the banks of the Medway, between Gillingham and Rainham parishes. In 1929, the large village of Rainham was absorbed into the borough.

Some points about the organisation of this book. Firstly, it contains few (if any) illustrations relevant to the dockyard and Naval barracks, even though, by the early twentieth century, most of the former and all of the latter were technically in the parish of Gillingham. This is because they were always commonly associated with Chatham, and we dealt with these in our companion volume *Chatham From Old Photographs*. Secondly, we have organised the pictures to reflect the various communities that make up Gillingham. You will find sections devoted to the original Gillingham village, Brompton, New Brompton, and Rainham and Wigmore.

Lastly, the high street east of Canterbury Street, originally known as Railway Street, was largely residential. To the west, New Brompton high street developed to meet the shopping needs of the new township. Once Gillingham Council was created in 1903, the two were known together as Gillingham High Street. For reasons of clarity and consistency, we have referred to the entire thoroughfare as Gillingham High Street throughout the book.

We leave our exploration of the area when Gillingham was at the height of its development, on the eve of the Second World War. What has happened since is another story.

Gillingham Village

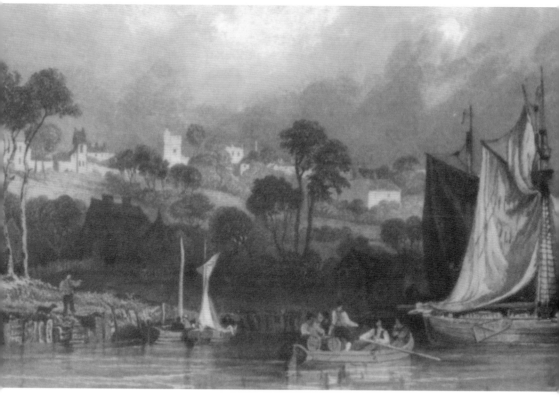

Gillingham Village
This early nineteenth-century print shows the part of the river close to today's Strand Leisure
Park. The parish church may be seen on the horizon. To the right, the observer may spot
Gillingham House. The buildings on the left probably include surviving portions of the medieval
Archbishop's Palace. Despite being close to Chatham Dockyard, Gillingham's economy was based
on agriculture and fishing, and the village retained its rural charm.

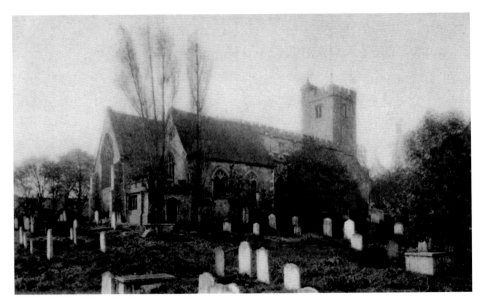

St Mary Magdalene Church – Origins

The original church building, constructed in the Norman period, probably stood within the confines of the now demolished Archbishop's Palace. This residence was intended to accommodate archbishops of Canterbury, who were regular visitors to Gillingham. The church would probably have been the palace's chapel. Some Norman features have survived – for example, the twelfth-century arches that separate the chancel from the side chapels.

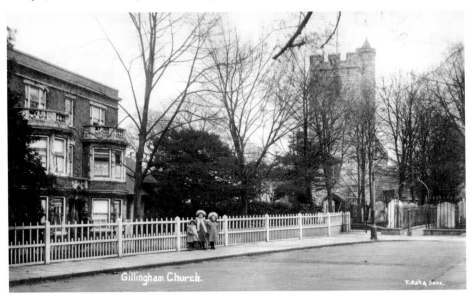

Gillingham Church.

T. Ash & Sons.

St Mary Magdalene Church – Development

The church tower dates from the fourteenth century and is constructed of Kentish rag-stone. It served as a navigational aid for ships sailing in and out of the River Medway. To help captains see the tower at night and in fog, a lamp was lit. Most of the church building dates from the fifteenth century and is mainly of flint. A Victorian renovation led to the replacement of all the stained glass. The nearby vicarage is now demolished.

Right: Canon William Robins
This clergyman became the vicar
of Gillingham in 1878. As a young
man, Robins had been injured by a
cricket ball, leaving him totally blind.
His parents sent him to the College
for the Blind Sons of Gentlemen
in Worcester. He was eventually
ordained in 1875. During his time in
Gillingham three mission churches
opened – Twydall (1886), Gad's
Hill (1902), and Hempstead (1911).
Robins retired in 1915 to live in
Restoration House in Rochester. He
died in 1923.

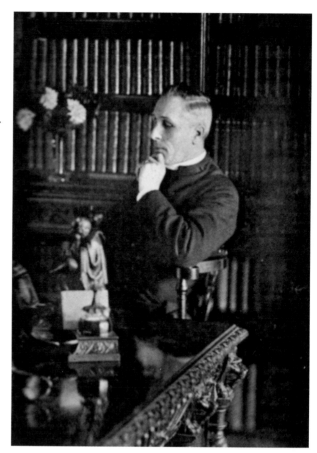

Below: Church Street
This is the heart of the original
village of Gillingham. The road
on the right is Gillingham Green,
leading to the parish church. The
pub on the left is the Five Bells, once
the meeting place of archaic parish
institutions such as the court leet.
The hill leads down to Pier Road
and the River Medway may just be
spotted in the distance.

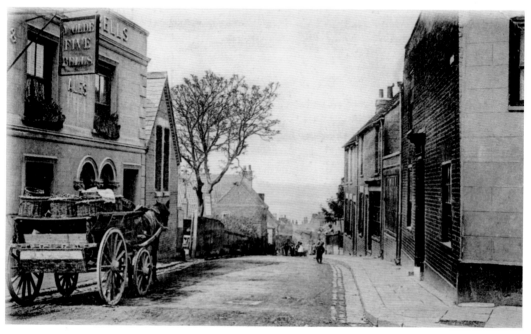

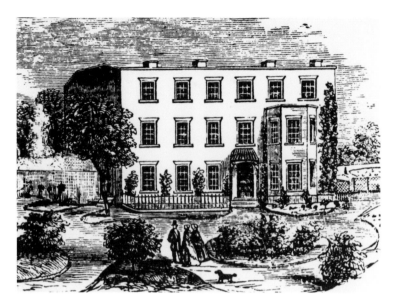

Gillingham House, Pier Road

This residence was reputedly built in the late eighteenth century by William Dann MP. It was on high ground overlooking the river and Commodore Hard, later transformed into the Strand Leisure Park. At various times its address was described as being at Christmas Street, Gad's Hill and Gillingham Lane. In the mid-nineteenth century, the house became a school. Later, for many years, it was owned by the Revd Blaxland. Gillingham Borough Council purchased the house in 1955 and eventually demolished it to make way for council housing.

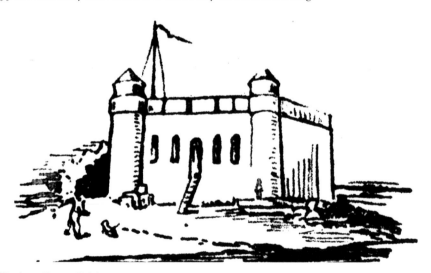

Gillingham Fort – Origins

To help protect Chatham Dockyard against enemy attack, Gillingham Fort was constructed on a small island at the mouth of St Mary's Creek. A drawbridge connected the fort to the shore. Guns were installed to protect it from both the river and landward sides. It was surrounded by ramparts of wood and earth. Gillingham Fort never saw action, although during the Napoleonic period a red brick Martello tower, accommodating two 18-pounder guns, was added to the site. This picture dates from 1847.

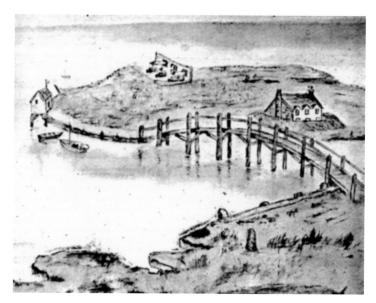

Gillingham Fort – Decline

After 1815 the fort began to deteriorate and was used for other purposes. In 1833, a house, garden and 5 acres of land were advertised to let at the fort. In 1859, the complex was declared obsolete and, in 1862, the Royal Engineers demolished the Martello tower. The site was used as a coastguard station until it disappeared under Chatham Dockyard's Victorian extension. This drawing appears to show the site after most of the military structures were demolished.

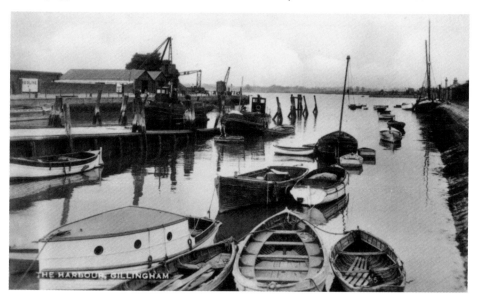

Gillingham Harbour

Work on the Chatham Dockyard extension began in the mid-1860s. One of the consequences was that the old Gillingham parish wharf was swallowed up by the development. To compensate the village, the Admiralty agreed to finance the building of a new wharf and access road adjacent to the dockyard boundary wall. The proposed facility was planned to be 600 feet long and 100 feet wide, with a dock for the loading and unloading of barges.

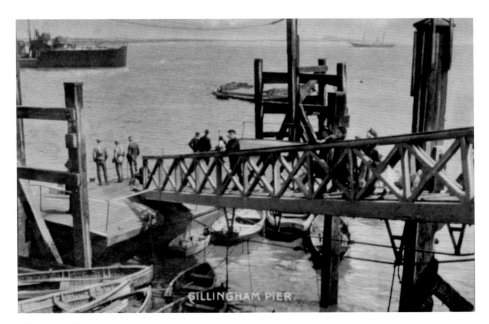

Gillingham Pier
The work was planned to take two years, but the foundations were difficult to install due to the deeper than expected soft mud. The wharf, complete with a floating dummy used by steamboats as a landing stage, was handed over to the Gillingham board of surveyors in 1872. The formal opening took place in February 1873, but work continued for a further two years.

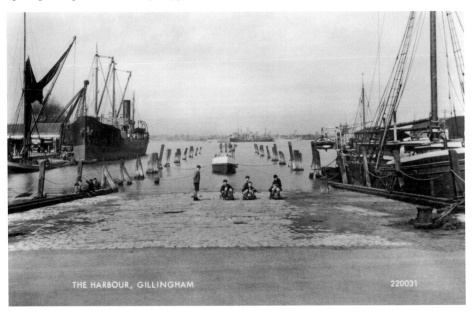

Harbour Scene
The wharf was used by a wide range of working vessels, which included coastal ships, Thames barges and pleasure craft. Note the warships anchored further out. The facility also served as an adventure playground for small boys. Today, accommodation for university students overlooks this riverside view.

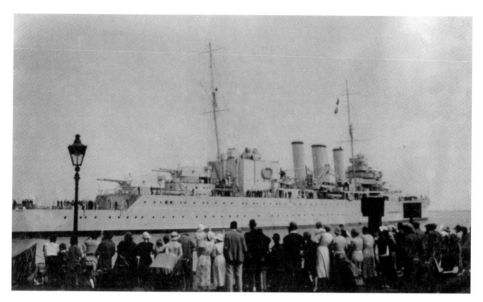

HMS *Cumberland*, 1928

Sights like this were common when Chatham had a working dockyard, but must still have been awe-inspiring. This County Class heavy cruiser was launched at Barrow-in-Furness in 1926. The vessel was photographed passing Gillingham Pier, probably on her way to the China Station, where she spent the next ten years. Having seen sterling service in the Second World War, she was finally scrapped in 1959.

❈ CUCKOW'S ❈

PUBLIC SEA-WATER

SWIMMING BATH

GILLINGHAM HARD, (PIER ROAD).

Open from May to September. Admission : Adults, 2d. ; Boys under 12, 1d.

TOWELS AND SWIMMING DRAWERS ON HIRE, 1d. EACH.

The Bath is well enclosed, and the depth ranges from 3 ft. to 8 ft.

Cuckow's Swimming Bath, 1896

Every summer without fail, there were several incidents where some boys and young men swimming at Commodore (aka Gillingham) Hard drowned. Thomas Cuckow, a local baker who had rescued several youths from the river, campaigned for a safe swimming place for many years. After more than a decade of bureaucratic delays, he was able to lease marshland at the Hard and construct a swimming bath. From then onwards, males were able to swim safely in river water, allowed in by sluices.

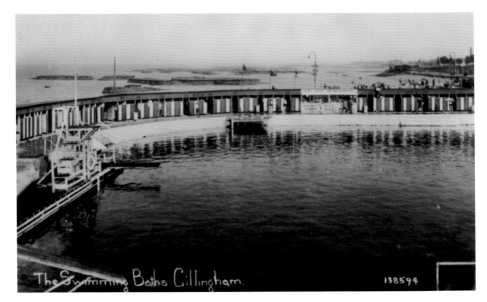

The Swimming Baths Gillingham. 138594

Swimming Bath – Improvements
Odours from the neighbouring gasworks, sewage outfall, and rubbish heaps marred the experience somewhat. A visiting journalist claimed he provided himself with 'a respirator, a pound of smelling salts and a couple of gallons of Condy's Fluid'. In 1915, Gillingham Council took over and substantial improvements were made: the original changing rooms based in old railway carriages were replaced, the pool was emptied fortnightly and occasionally chlorinated. For the first time the sexes were desegregated.

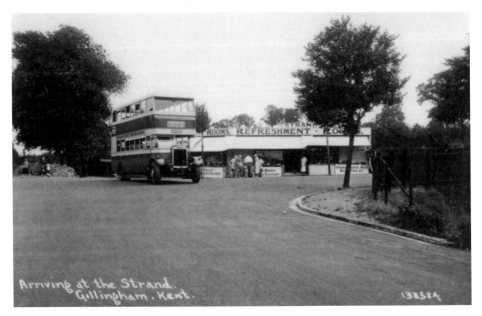

Arriving at the Strand. Gillingham. Kent. 138584

The Strand – Entrance
In the 1920s, the council purchased land adjacent to the swimming pool and converted it for leisure purposes. The entire complex became known as The Strand. In this picture the Chatham and District Leyland Titan stands outside the café. Even at this early stage a car park was also provided.

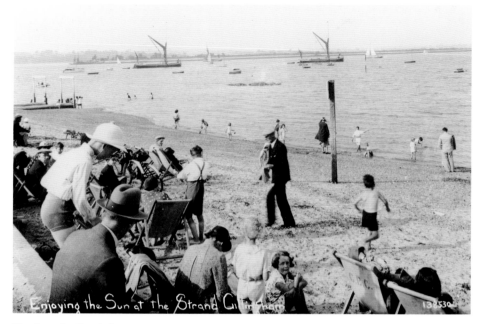

The Strand – Beach Scene

Tons of sand were dumped on the muddy shoreline and an artificial beach was created. The Thames barges off shore and Chatham Dockyard on the horizon remind us that The Strand was an urban facility. Notice the suits worn by male beach-goers in the more formal pre-war era.

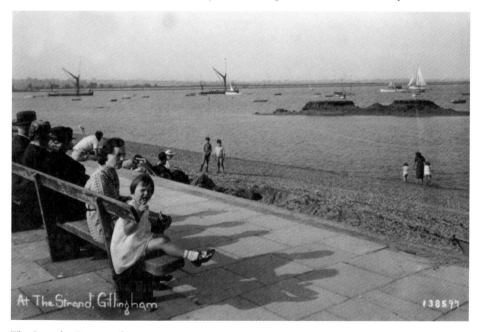

The Strand – Promenade

The Strand clearly appealed to residents and strangers alike. The writer of this postcard in July 1938 was reluctant to return to London: 'Today I'm leaving for stuffy Acton ... What a nice change and rest I've had, a whole fortnight away.'

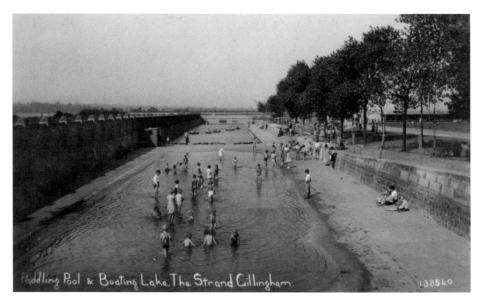

The Strand – Paddling Pool and Boating Lake
The boundary between The Strand and the neighbouring gasworks was a polluted creek. By 1936, the gas company had donated their half to the council. It was proposed to convert the creek into a boating lake and children's paddling pool to encourage youngsters away from the unhealthy river mud. Nearly £9,000 was borrowed from the government, and the facilities opened in 1937. In 1995, a new paddling pool was constructed after both pools were filled in and grassed over.

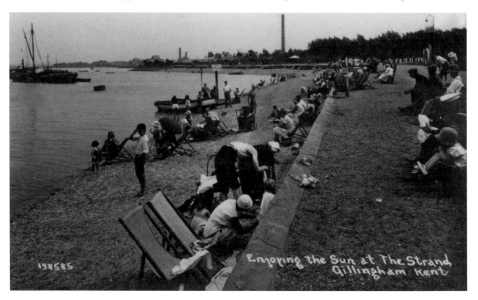

Looking Eastwards from The Strand
During the interwar period, the council extended The Strand in the Rainham direction. As well as lounging on the beach, holidaymakers had an option of a river boat trip. The chimneys of the nearby cement works in the horizon remind us that The Strand was very much an oasis in an urban landscape. In the late 1980s, protests prevented the council from closing The Strand. Improved and renovated, it continues to fulfil its original purpose.

Brompton

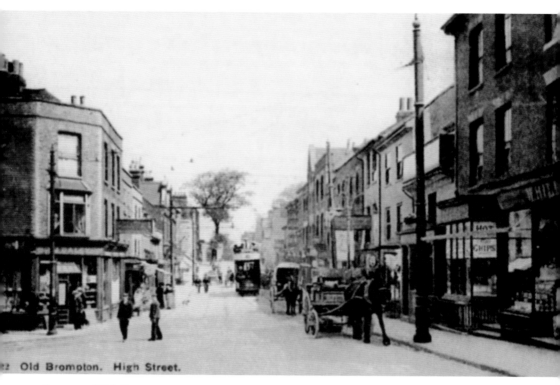

Old Brompton. High Street.

Brompton High Street
This view from the corner of Middle Street looks towards the School of Military Engineering.
Mrs Jane Daley's Dining Rooms may be seen on the left. The shops on the right include William
Hill's grocer's shop, a fried fish shop and at No. 39, the Alton Ale House. An approaching tram
suggests that the picture was taken after June 1902 when the system became operational. Mrs
Daley had sold her business by 1907, so the picture probably dates to around 1905.

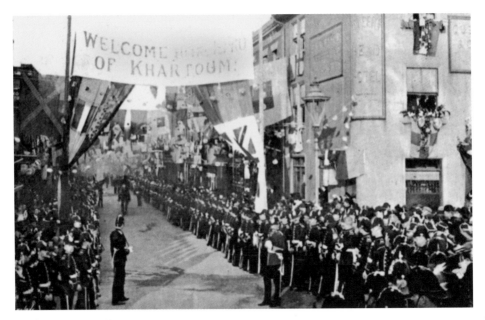

Kitchener's Visit to Brompton, 1899

Having avenged Gen. Gordon's death by seizing Sudan, 'Kitchener of Khartoum' was invited to attend a banquet at Brompton Barracks. After formalities at Chatham station, an eight-carriage procession took him to the highly decorated Brompton High Street and into the barracks' square. The band played 'See the Conquering Hero Comes' as he arrived. Kitchener was driven past an honour guard through the Crimea Arch to the RE Institute. The private banquet that evening was held in the officers' mess, after which Kitchener rejoined his special train and returned to London.

Holy Trinity Church, Brompton – Origins

The Wesleyans and Roman Catholics had places of worship in Brompton long before the Church of England did. Anglicans could always walk to the nearby St Mary's church at Chatham. However, in 1848, Canon William Conway, the vicar of St Margaret's Rochester and his sister, Martha, financed the building of Holy Trinity on former War Department land at the end of Mansion Row.

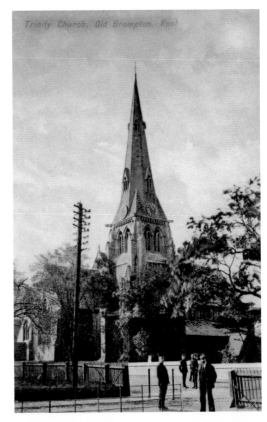

Holy Trinity Church, Brompton – Rise and Fall
The Kentish rag-stone building was designed
by well-known architect Samuel Daukes. The
church's Gothic spire, its most notable feature,
served as a conspicuous landmark. A clock
was added in 1862 – a memorial to Prince
Albert. In the early twentieth century, scandals
involving the vicar alienated the congregation,
who boycotted the church. The building
deteriorated, but the Rochester Diocese refused
to pay for repairs. Declines in both religious
observance and the Brompton population led
to the area losing its parish status in 1953. In
1958, Holy Trinity was demolished.

James McCudden, VC
McCudden was born in Brompton in 1895.
Having attended the Royal Engineers Garrison
School, at fifteen he joined the engineers as
a bugler. In 1913, McCudden transferred
into the Royal Flying Corps as a mechanic,
rising to the rank of captain during the
Great War. Qualifying as a pilot in 1916,
he soon established himself as a flying ace,
claiming scores of 'kills'. Medals for bravery
accumulated, culminating in the award of the
Victoria Cross in March 1918. He did not live
to collect it, having died in a flying accident.
McCudden was posthumously awarded the
Freedom of the Borough of Gillingham.

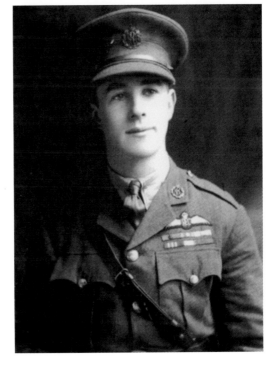

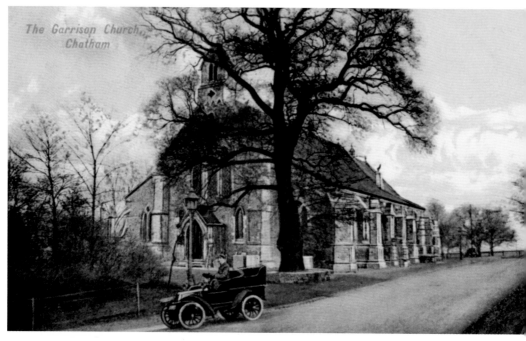

The Garrison Church, Chatham

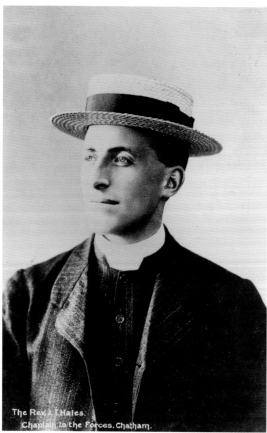

The Rev. J. T. Hales. Chaplain to the Forces. Chatham.

Above: Garrison Anglican Church, Brompton

This place of worship is now known as St Barbara's. It was situated in a continuation of Mansion Row, then known as Military Road. This has since been renamed Maxwell Road. During the Edwardian period, the road accommodated Holy Trinity Church and schools, the vicarage, the Conway Memorial Hall, and various military residences. Beyond all these properties lay the entrance to the Chatham Barracks complex.

Left: Revd James Tooke Hales

Having served in several parishes, Revd Hales became an army chaplain during the Boer War. By 1901 he was living at No. 6 Mansion Row in Brompton. During the next eight years, the clergyman encouraged his flock to keep fit by playing football, and acted as secretary to the Army's Football Association. In 1909 he left for China. In 1914, Hales was captured by the Germans, but released the following year. After the war he was posted to Mesopotamia. Hales spent his final years in a Canterbury parish and died in 1939.

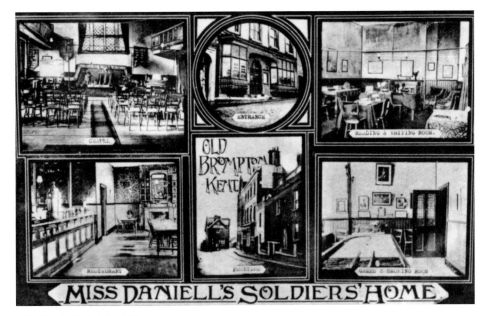

MISS DANIELL'S SOLDIERS' HOME

Miss Daniell's Soldiers' Home
Mrs Daniell, the widow of an army officer, opened her first soldiers' home in Aldershot in 1863. After her death in 1871, her daughter continued the work and opened more homes, including one in Pleasant Row, Brompton. Her aim was to provide decent accommodation and respectable leisure pursuits for soldiers. The Brompton Home contained clean beds, a teetotal canteen, reading rooms, a chapel and so on. While this home closed in the mid-1960s, 'Miss Daniell's Soldiers' Homes' still exists elsewhere as a registered charity.

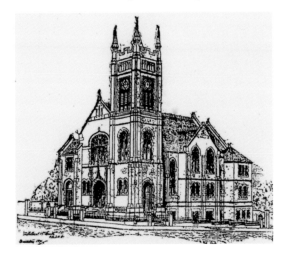

Wesleyan Garrison Church, Brompton
This building, constructed of Kentish rag-stone with Bath stone dressings, and a 75-ft high tower at its north-west corner, opened in 1892. This was the only Wesleyan church subsidised by the government. The Admiralty donated the site in Prospect Row and the War Department contributed towards construction costs. In return, the church reserved some of its pews for Methodist soldiers and sailors. Religious services ended in 1946, after compulsory church parades for servicemen were abolished. The building was finally demolished in 1962.

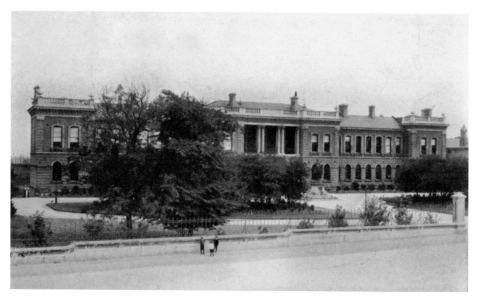

Royal Engineers Institute
The Duke of Cambridge, commander-in-chief of the British Army, laid the foundation stone of the institute in May 1872. It opened the following year. This imposing building was designed by Lt Montagu Ommaney RE in an Italianate style. The institute was intended to house the Royal Engineers Museum library, teaching facilities and offices. It is now the headquarters of the Royal School of Military Engineering.

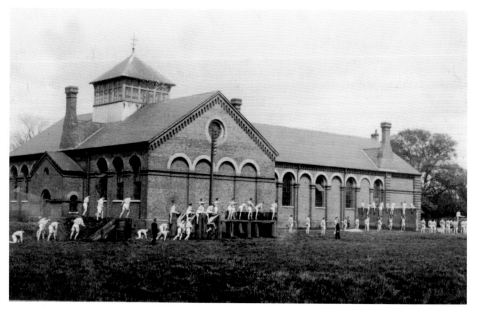

Military Gymnasium, Brompton – Exterior
This building opened in 1864. It was constructed to a basic pattern common to the other seven military gymnasia situated around the country. Its tower's inner walls provided the soldiers with an opportunity to practise their climbing skills. An annexe housed the officers' fencing school. The building still exists and, having been updated several times, continues to fulfil its original function.

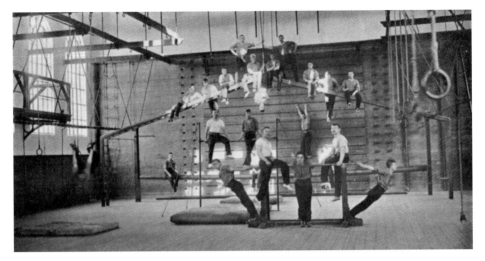

Military Gymnasium, Brompton – Interior

The gymnasium was divided into two sections. The first – the 'school of arms' – did not contain any fixed equipment, enabling the men to practise fencing and sword and bayonet drills. The other section housed horizontal bars, vaulting horses and climbing ropes. Two walls were fitted with a variety of surfaces. It allowed soldiers to practise their climbing skills in different conditions. Netting was installed underneath in case of accidents, and the floor was fairly elastic to absorb the impact of a fall.

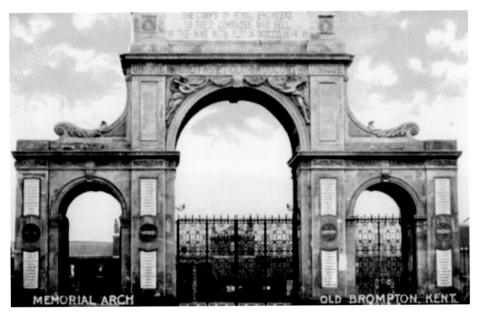

Crimean Arch

The Duke of Cambridge laid the foundation stone of this structure in 1872. It records the names of the 23 Royal Engineers and 161 Royal Sappers and Miners who died in the Crimean War between 1854 and 1856. The cost of the arch, designed by Sir Matthew Digby Wyatt, was borne by subscriptions from all ranks of the regiment. Its gates were reputedly made from Russian guns captured during the war. The remains of Snob, a dog rescued by British troops during the Battle of Alma, are buried nearby.

Left: Gordon Statue
Gen. Charles Gordon was one of the great figures of the Royal Engineers. His statue at the School of Military Engineering, designed by Onslow Ford, was unveiled by Edward, Prince of Wales in 1890. It showed Gordon dressed in the uniform of an Egyptian general that he wore when Governor General of Sudan. The Gordon Boys' Home in Dover was created for orphan boys in memory of Gen. Gordon soon after his death in 1885.

Below: Unveiling of the South African Arch by King Edward VII, 26 July 1905
At 12.20 p.m., a royal salute fired from Fort Amherst, which signalled that the King had left Chatham station. On the royal carriage entering Brompton Barracks, a whistle blew and the troops snapped to attention. After formal speeches, the King pushed a button, electrically removing the Union flags draped over the arch. Troops fired three volleys; the RE band played pieces including 'The Last Post' and 'Onward Christian Soldiers'. Edward turned the soil for the planting of an oak tree. He was then driven to the Royal Naval Hospital, also to be opened that day.

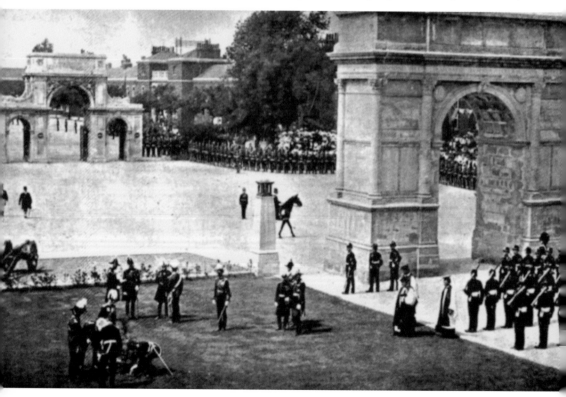

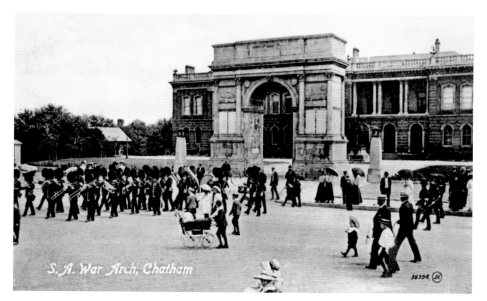

South African Arch

The arch was designed by the architect Edward Ingress Bell, also known for designing the frontage of the Victoria and Albert Museum in London. The marble tablets of the arch list the names of the 420 men from the Royal Engineers who died during the Boer War of 1899–1902. Some panels display scenes from battles that involved the Corps; others show the engineering work undertaken in South Africa, such as the construction of blockhouses and pontoon bridges.

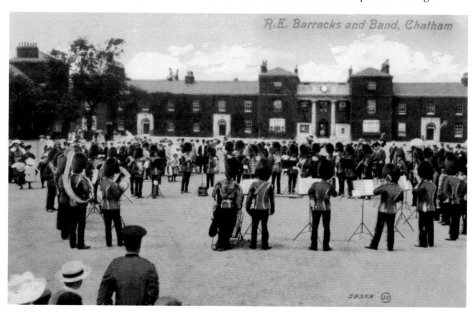

School of Military Engineering – Band Concert

The Edwardian photographer had his back to the Crimean Arch when recording this scene one summer's day. Together with the audience, he was probably enjoying a selection of tunes from the locally famous RE Band. Notice that many children have been allowed to stand at the front of the crowd.

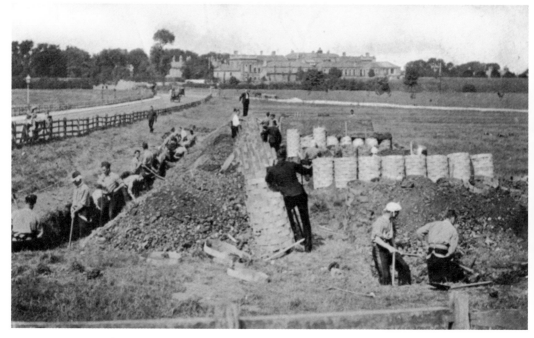

Sappers at Work

Civilian passers-by lean on the fence observing these sappers practising their trench digging skills. This is hot work, although the NCO lounging in the middle of the picture appears to be fairly relaxed. Notice the buildings of the School of Military Engineering in the background.

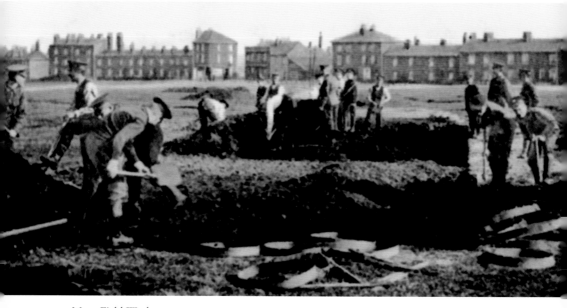

More Field Work

These soldiers, this time dressed in khaki issue uniforms, are filling in a trench system that is no longer required. Undoubtedly this ground would have been dug out repeatedly by later groups of sappers. Behind them are the houses and shops of Mill Road.

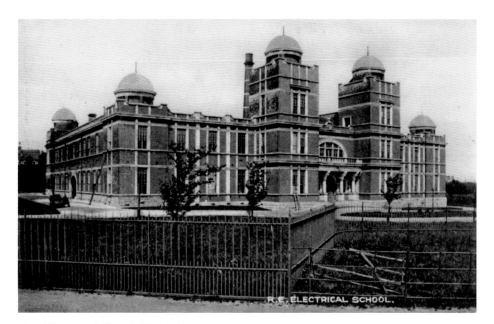

Royal Engineers' Electrical School
The exterior of the impressive building that housed the Royal Engineers' Electrical School is not very different in design from that of the Royal Naval Hospital in Gillingham. Both date from the Edwardian period and have a similar, almost Byzantine, appearance. It was known as the Ravelin Building, after an angled defensive salient that previously stood on the spot. It now houses the Royal Engineers Museum.

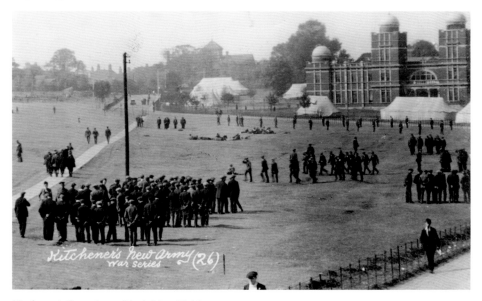

Kitchener's Recruits at Black Lion Field
Shortly after the outbreak of war in August 1914, thousands of recruits flocked into Gillingham. Such was the enormous response to Kitchener's call for volunteers that there was a shortage of uniforms. Some of these men may be seen drilling in their civilian clothes outside the Royal Engineers' Electrical School. The roof of the Military Gymnasium may be seen in the background.

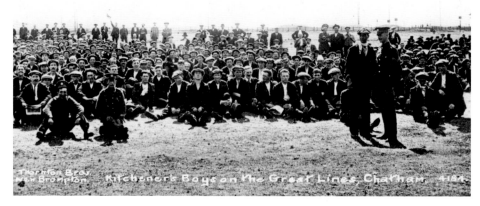

1914 – Volunteers on the Great Lines
The men in this photograph, still in civilian clothes, are assembled on the Great Lines in Gillingham. Soon a tented camp would be constructed on the Lines to accommodate 'Kitchener's men'. Others would be billeted in private homes throughout the town, or in large premises such as the newly opened Co-operative hall in the High Street.

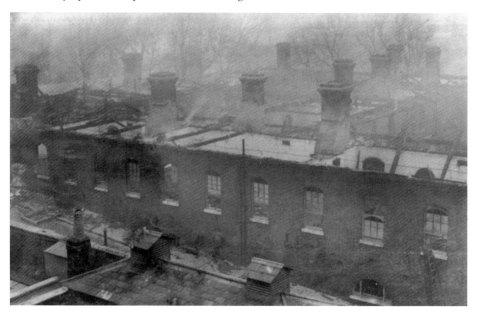

Fire at the Royal Engineers Barracks, January 1916
North-Square Barracks consisted of stables with soldiers' accommodation above. One Saturday evening, flames were spotted shooting from a fodder store. Firefighters from among the sappers, the dockyard police, fire brigade and sailors from the Naval Barracks descended on the scene, soon joined by steam fire engines from the Chatham and Gillingham Brigades. Chaos ensued. Many hydrants were used and the water pressure dropped dramatically. The roof fell in and walls on the west of the square collapsed. By the morning the whole square was almost gutted.

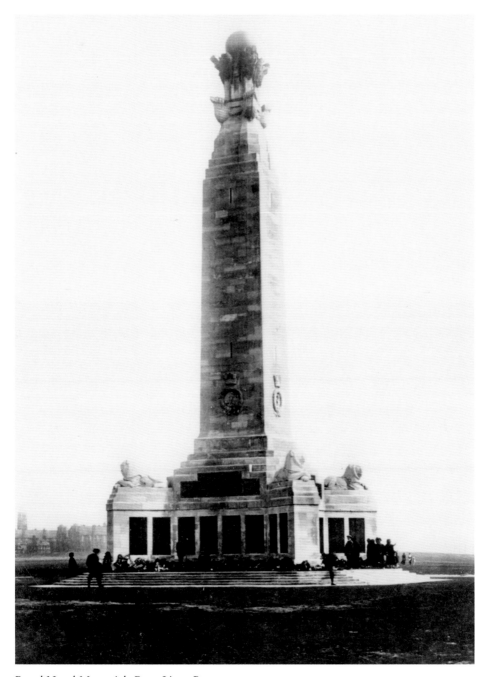

Royal Naval Memorial, Great Lines, Brompton, 1924

To commemorate the naval dead of Plymouth, Portsmouth and Chatham who had no grave, three memorials were designed by Sir Robert Lorimer. The Chatham Memorial overlooks the town. Unveiled by Edward, Prince of Wales, it consists of a Portland-stone obelisk supported by four buttresses, inscribed with the names of the dead. It was surmounted by a copper sphere, supported by figures representing the four winds. After the Second World War, a Portland-stone surround was added, which contained a further 10,000 names.

New Brompton

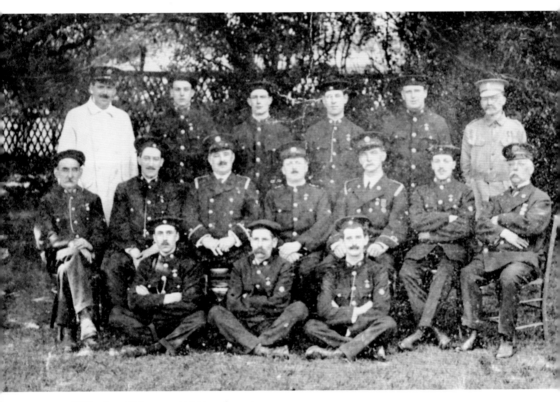

Gillingham Voluntary Aid Detachment
In 1909, the VAD organisation was created jointly by the British Red Cross and St John Ambulance to provide a voluntary nursing service. In 1914, the VADs came forward to aid the war effort, both at home and abroad. Kent 45 (Gillingham) Detachment consisted mainly of firemen who also volunteered for ambulance work. Its commandant was George Peddle and secretary W. Plewis. Section leaders included E. Annett, E. P. Bines, G. H. Hillisley and W. J. Young.

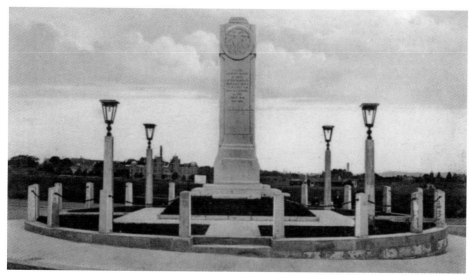

Gillingham War Memorial

Made of Portland stone and 20 feet high from its plinth, the memorial was designed by Francis Doyle-Jones to commemorate the dead of the First World War. The relief carving at the top symbolises the sacrifice of youth on the altar of patriotism. The borough surveyor created the monument's circular enclosure complete with paths and lamps. It was unveiled at the junction of Mill Road and High Street in July 1924 – the last to be constructed in the Medway Towns. In 1985, it was moved several yards to the west in order to improve traffic flow.

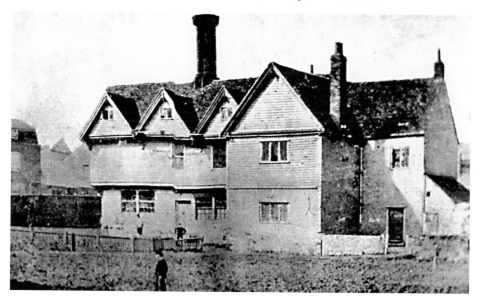

Britton Farm House

This large farmhouse had quite a few fascinating features: its octagonal chimney dates back to the Elizabethan period; the bricked-up spaces suggest former windows, implying that its owners avoided the window tax of the eighteenth century. By the mid-nineteenth century, New Brompton was encroaching and, in 1862, the house and farm were sold for development. High Street shops and residential streets now cover the site, but the farm lives on in road and pub names.

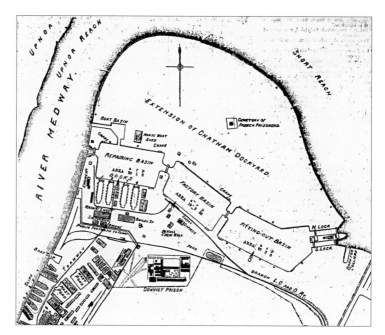

Chatham Dockyard Extension

The government had been buying up land to the north of Chatham Dockyard for several years before an Act of Parliament of 1861 allowed for its extension. Much of the 380 additional acres comprised the marshy St Mary's Island, which lay within Gillingham parish. Centre pieces of this work were three large basins for the repair and fitting out of ships developed from the former St Mary's Creek. After the extension's completion in the 1880s, most of Chatham Dockyard actually lay within Gillingham.

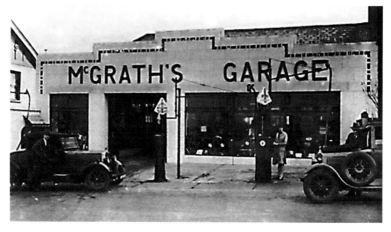

McGrath's Garage, Mill Road

This firm began as E. McGrath & Co. Cycle Agents, with premises in Arden Street and Britton Farm Street. By 1908, the company had diversified into motor engineering, with works on Mill Road near its junction with the High Street. As motor traffic increased after the First World War, McGrath's expanded. By 1939, the firm had divested itself of its cycle premises. Shortly after the Second World War, the Mill Road site was sold to the Jubilee Clips Company and the long established firm of McGrath's was no more.

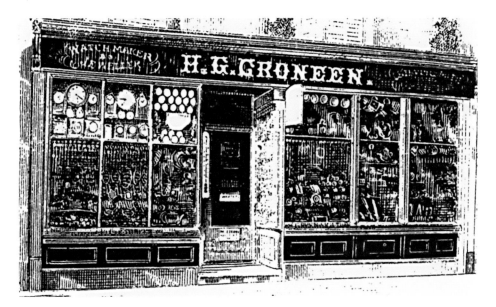

Horace Croneen's Jeweller's Shop, High Street
The Croneens were one of Gillingham's leading business families. William Croneen owned the Lord Hardinge public house on the corner of the High Street and Park (now Marlborough) Road between 1850 and 1911. His main business activity was brick making around Gillingham and New Brompton. William's son, Walter, helped in the running of the pub while Horace was a jeweller in a shop a few doors away. The brothers inherited the brick making business and the Lord Hardinge pub on their father's death in 1911.

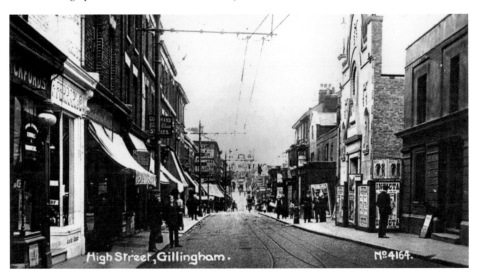

Invicta Picture House
After their father's death, the Croneens diversified into film exhibition. Horace's shop, the cottages between it and the pub were demolished. The cinema opened at Easter 1914. It was designed by E. J. Hammond, a Gillingham architect. Its frontage, finished with ornamental cement, contained an illuminated panel showing a white horse rampant. In 1931, the brothers opened the Plaza in Duncan Road. The Invicta then became a theatre. It ended its life as a car showroom before demolition.

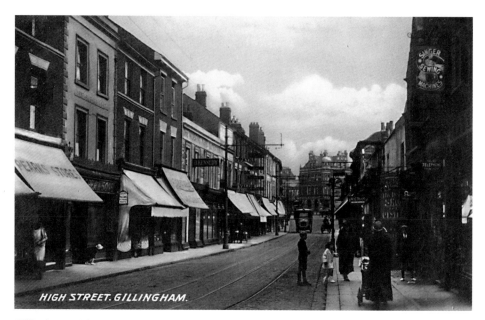

Gillingham High Street – Facing East, 1920s
On your way to Barclays Bank (formerly The London and Provincial), you would have passed, at the corner of Britton Street on your right, the Singer Sewing Machine premises. Next door was the shop of George Fieldgate, an oyster merchant. Opposite were Peark's grocery and Jasper & Sons, the bakers, followed by Beverages Chemists and Douglas Kennedy's 'Workmen's Outfitters'.

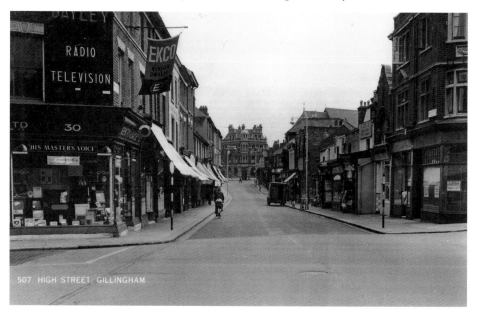

Gillingham High Street – Facing East
When proceeding to Barclays nearly thirty years later, one would have passed a florist in the former Singer's premises, although the adjacent shop still sold shellfish. Television is being advertised outside the shop of Gentry and Bayley, and yet the High Street is virtually devoid of traffic. This implies that the image was taken in the early 1950s.

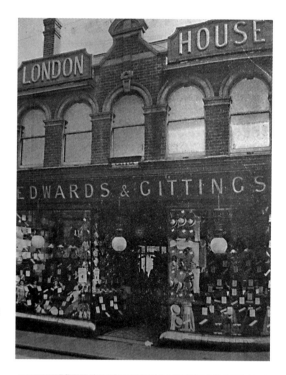

Edwards & Gittings, London House,
Nos 76–78 High Street
In 1897, two cousins – Edgar Edwards and
John Gittings – set up a men's outfitters.
This shop was to become one of the most
prestigious in Gillingham. Both cousins
were in their twenties and came from a
tailoring background. Edgar, the son of
Robert Edwards, a master tailor and a future
Gillingham councillor, had learnt the trade in
London before moving to Gillingham. Gittings
had been an outfitter's assistant in Ramsgate.
Edwards retired in 1906, but the business
continued to trade under its original name.

Edwards & Gittings
The business went from strength to strength
and in 1930, opened a branch in Chatham.
In 1947, Gittings took two of his family into
partnership. They carried on the business
after his death in 1958. The spread of chain
stores threatened traditional men's outfitters
such as this, and the Chatham branch closed
in the 1960s. In the early 1970s, the London
House premises themselves were taken over
by A. M. Pope, a photographer. The building
is now a charity shop.

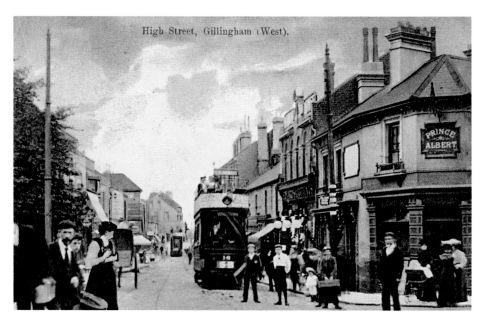

Gillingham High Street – West

This view, dating to around 1904, shows the junction of the High Street and Skinner Street to the right and Canterbury Street to the left. At that time, the licensee of the Prince Albert was Mrs E. Morgan. Beyond her pub is London House, the business of Edwards & Gittings, the outfitters mentioned above.

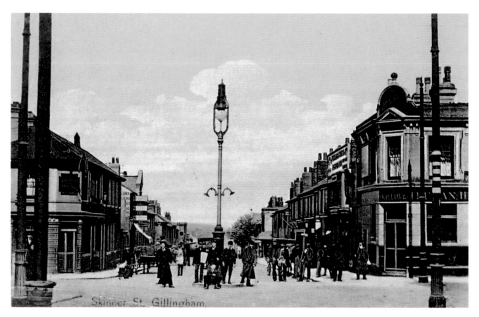

Skinner Street

Two pubs – the Prince Albert and the British Queen – mark the start of Skinner Street. This thoroughfare saw great changes in the early twentieth century – the new post office housed in the gabled building, opened in 1902. The Grand Picture and Variety Theatre opened in 1910 on the spot where the tree is.

Right: Grand Picture and Variety Theatre
This venue, the second cinema in Gillingham, opened on Boxing Day 1910. The main entrance was set diagonally at the Skinner Street – Jeffery Street junction. The theatre's prime position was close to both the High Street and the acres of densely packed working-class housing. The Grand's most impressive feature was its huge gilt dome dominated by a statue of Venus. Films and variety acts shared the billing in its first three years, but, in 1914, the Grand abandoned live entertainment to concentrate exclusively on films.

Below: The Grand – Interior
The Grand could accommodate nearly 900 patrons. Filmgoers walked to their plush upholstered fauteuils on green velvet pile carpet – perhaps the first many customers had ever walked on. Ventilators in the ceiling alleviated the tobacco smoke problem and, in summer, roof sections could be slid open for additional air. The image shows the Grand in its cinema days, and the patrons' costume indicates that it was taken in the 1920s.

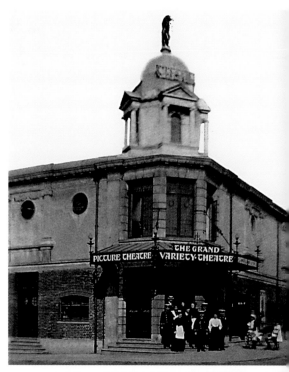

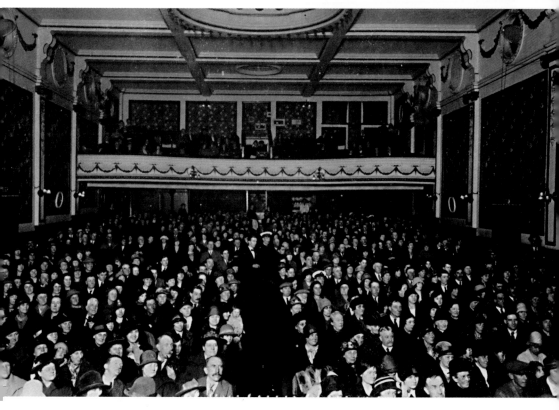

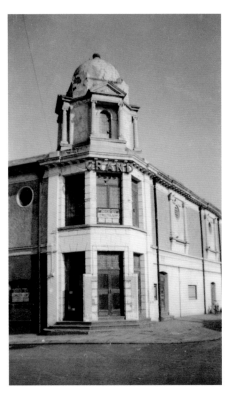

The Grand – Its Demise
While most cinemas were owned by large chains, the Grand always remained in private hands. It was rendered out of date when the so-called 'Super Cinemas' opened in the 1930s. The Grand was further damaged by the advent of television, particularly ITV in the 1950s. Attempts to keep it open by doing what television could not, such as showing X-rated continental films, could not save it. The Grand closed in 1960, was demolished and replaced by a tyre depot.

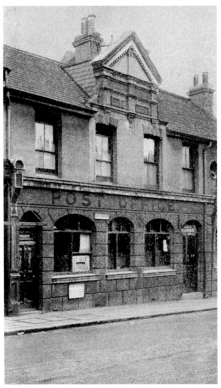

Post Office, Skinner Street
A new post office opened in 1902 to meet the requirements of the growing town. It drew criticism from the outset. The *Chatham News* complained: 'It has filled the townspeople with disappointment and disgust on account of its miniature dimensions ... Totally inadequate to supply the accommodation required by such a populous town.' The *Chatham Observer* agreed: 'Evidently officials at Head Quarters are in much ignorance of the requirements of the locality.' A petition to the government followed, but Skinner Street remained Gillingham's main post office for twenty-five years. It now sells kebabs.

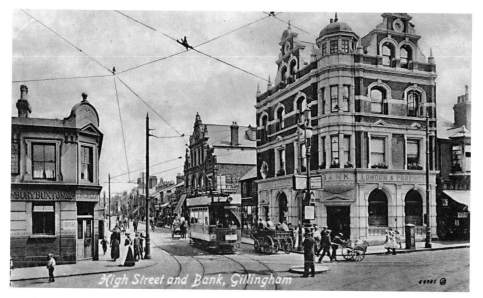

High Street and Bank, Gillingham

London and Provincial Bank

Gillingham's growing importance and prosperity were confirmed in 1901, when this four-storey building opened on the corner of High Street and Canterbury Street. Designed by George Bond, the prolific local architect, the bank is of Portland stone and red bricks. Banking dominated the ground floor, with imposing polished mahogany and ornamental tiles in the public areas. A spiral staircase led to the basement strong room. The upper floors were occupied by the manager's residence. The premises are still used as a bank.

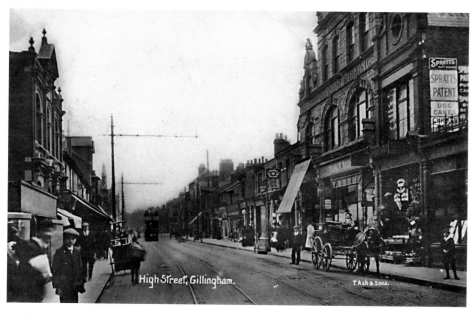

High Street, Gillingham.

High Street – East End

One may see Bank Chambers on the left, facing the newly constructed Carrara Building on the right. The latter contained the premises of Frank W. Masson, a tailor. The horse and wagon are standing outside a corn merchant's shop.

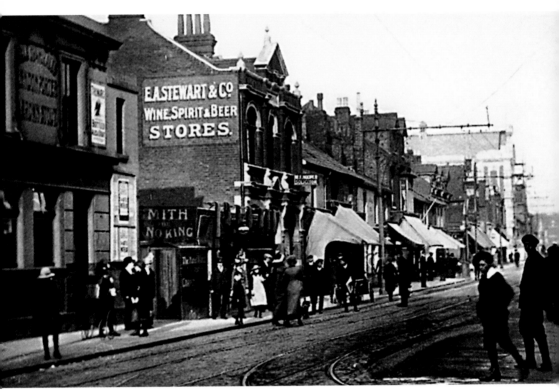

Above: High Street – East End Continued
In the foreground, tramlines curve round towards Canterbury Street, where the boys are crossing the road. Opposite, is the British Queen pub, and beyond it, Bank Chambers. Between the two buildings are the premises of Daniel Smith, a linoleum dealer. The Co-operative drapery and assembly hall looms in the background, indicating that the earliest this image could have been taken was 1914.

Left: Bank Chambers
Situated at No. 84 Gillingham High Street, Bank Chambers opened in the early 1890s. It was built to house the London and Provincial Bank, as well as other businesses such as solicitors and dentists practices. However, the other main occupant was E. A. Stewart & Co., wine and spirit merchant, seen to the left of the picture. When the bank moved to larger premises in early 1901, Frank Whibley, a hosier and shirt maker, moved in.

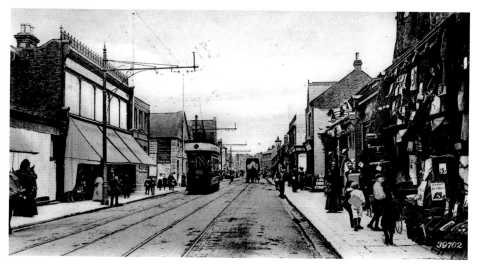

High Street – East End, Further On
The tramcar is outside the Gillingham Conservative Club, having just passed the premises of Jermyn, Smart and Smith Ltd. Gillingham public hall is beyond the tram. The tramway company's traction poles stretch towards the horizon.

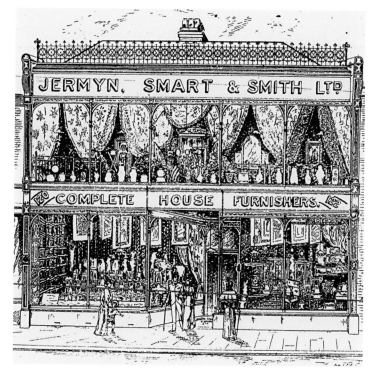

Jermyn, Smart and Smith, High Street
Having traded for eighteen years in Rainham, James Smart opened a drapery in New Brompton High Street in 1895. A few years later, with new partners, Jermyn and Smith, he established this furniture store opposite the corner of Gardiner Street and Gillingham High Street. In 1923, the business was acquired by Woolworths, who traded on the site until their demise in 2009.

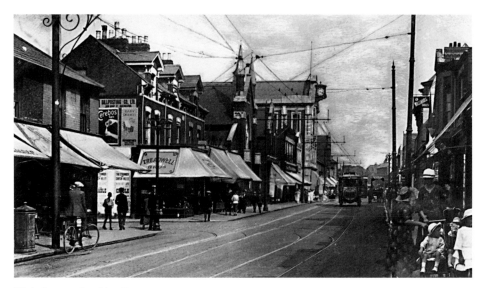

High Street – Looking East

The women's fashions and the presence of tramlines date this picture to the 1920s. On the left, on the corner of James Street, are the premises of Treadwell Bros, boot manufacturers. Just beyond it is the Congregational church and further on, at Nos 120–122, is Woolworths. The Conservative Club was, and still is, next door. The tall building is the Co-operative drapery and assembly hall. The people on the right have just passed Burton the Tailor, above which was a billiard hall.

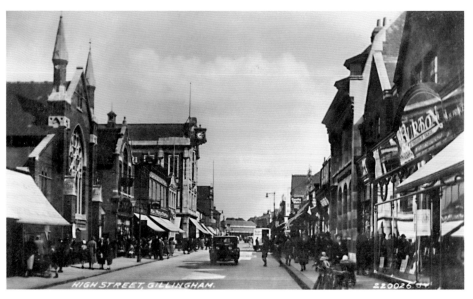

Gillingham High Street, 1930s

The tramlines have gone and the new Gillingham railway station may be seen on the horizon, indicating that this photograph was taken after 1932. The Congregational church and the Co-operative drapery and hall dominate the left of the picture. Between them are the Conservative Club and Woolworths store in the former shop of Jermyn, Smart and Smith. Burton the Tailor is on the right, with the Westminster Bank beyond it. The white van belongs to Scott & Son, dyers and cleaners, and is parked outside their premises.

Right: Congregational Church, High Street
In 1869, a Congregational church was built in Railway
Street, on land donated by the Mullinger family. The
red-brick building, with stone dressings and two pinnacles
surmounted by finules, dominated this part of the street.
Once Railway Street became part of the High Street,
the area turned increasingly noisy and inconvenient for
worshippers. In 1939, the Congregationalists moved to
quieter premises on Balmoral Road. This building was sold
to Littlewoods, who built an Art Deco store on the site.

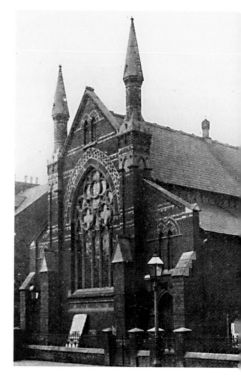

Below: New Brompton Public Hall, High Street
As New Brompton expanded, a respectable focal point
for entertainment and instruction was required. In 1875,
local businessmen formed a Public Hall Co. and began
fundraising. The public hall opened in 1877 to provide
the town with concerts, plays and dramatic recitals. Only
600 patrons could be accommodated – the ambitions were
modest. In 1911, the tenancy passed to Coley Goodman,
the proprietor of the Gem Picture House, who renamed it
the Lyceum. In 1913, the building was gutted by fire and
was never rebuilt.

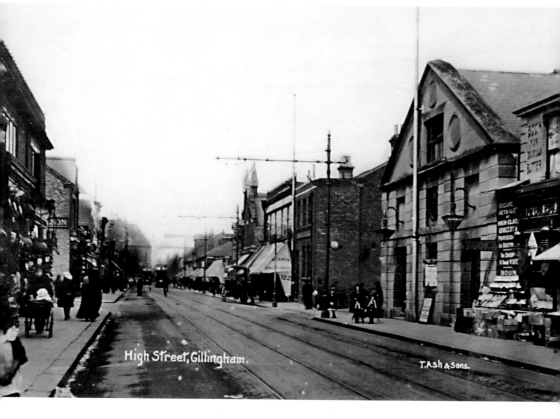

High Street, Gillingham.

T. Ash & Sons.

Gillingham Co-operative Hall and Drapery
The site of the former public hall was purchased by Gillingham Co-operative Society. They employed architects to design an imposing building of stone and red brick, with a green slate roof. The drapery occupied the ground floor, above which were the millinery and dressmaking departments. The second floor housed a 500-seat meeting hall. The formal opening ceremony planned for August 1914 had to be postponed due to the outbreak of war. Since the 1980s, new buildings have occupied the site.

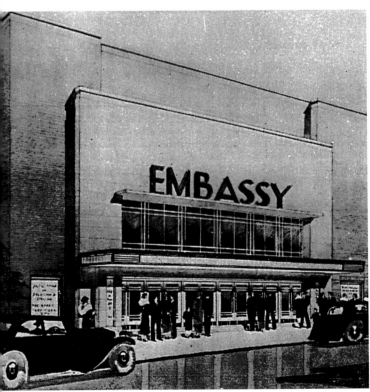

Embassy Cinema
In 1936, Bertie Garrett, the former owner of the King's Hall Cinema and Frederick White, and owner of a furniture shop, joined forces to build the Embassy in Gardiner Street. This new 'super-cinema' accommodated 1750 patrons and had a café on the first floor. In 1938, Garrett and White sold the Embassy to the Odeon circuit. It closed to make way for a bingo hall in 1977.

Post Office, Gardiner Street
The inadequacies of the
Skinner Street post office
caused new premises to be
built in 1926. This red-brick
structure had twice the
public space. The premises
contained state of the art
features, including telephone
kiosks and post boxes inside
and out, and automatic
stamp dispensers. The top
floor was reserved for the
telephone exchange, although
temporarily the 'hullo girls'
remained at Skinner Street.
At the time of writing, the
building is empty. The post
office is now sited in the
premises of WHSmith.

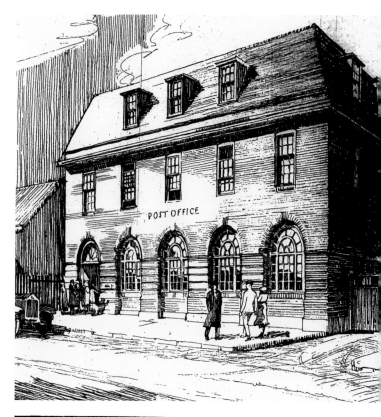

Gillingham Technical
Institute, Green Street
Gillingham Education
Committee opened this
building in 1893. The firm of
Seager of Sittingbourne built
the institute to a design by
George Bond. Externally, it was
described as being in the 'free
Renaissance' style. Internally,
large classrooms dominated
the ground floor, while the
first floor was taken up by two
art rooms and a tiered lecture
theatre. The building ended
its life as an adult education
centre in 2013, and has been
converted into flats.

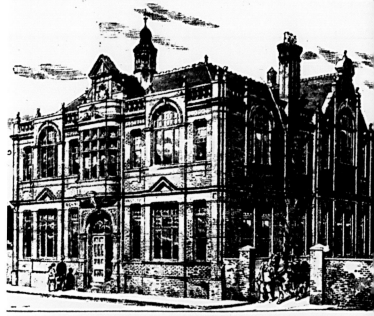

THE NEW TECHNICAL INSTITUTE AT GILLINGHAM.
Designed by Mr. G. E. Bond. Built by Mr. Laurance Seager.

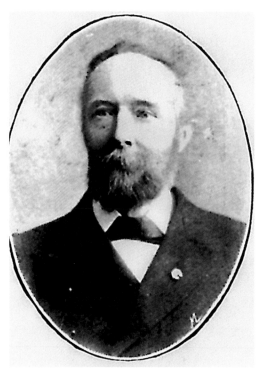

Revd Walter Blocksidge
A Birmingham jeweller, before he attended the Baptist College, Blocksidge, was sent to New Brompton as a paid preacher in 1878, while still a student. He created a church of sixteen members, and began fundraising for a Sunday school/church building. It opened in Green Street in 1881, with Blocksidge as pastor. The congregation grew rapidly, and a new church opened on the Green Street site in 1889. In 1925, Blocksidge retired to Surrey. In 1935, he returned to Gillingham and died two years later, aged eighty-six.

Baptist Tabernacle, Green Street
A Baptist school-chapel, built in 1881, was demolished in 1888. It was replaced by the Tabernacle, which opened the following year. This was built of brick with Kentish rag-stone facings at the front. The school rooms would be accessed by a pavement entrance. The church proper, accessed by the steps, was capable of accommodating nearly 650 worshippers. Designed by John Wills of Derby and built by Naylar of Rochester, the Tabernacle continues to serve Gillingham's Baptist community.

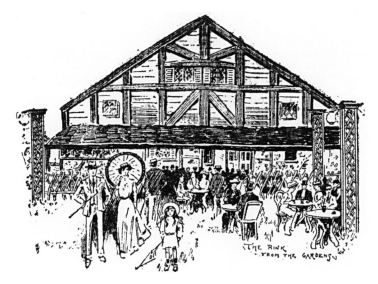

Hippodrome

In 1904, a temporary prefabricated wooden building was opened in Croneen's field, near Balmoral Road. The Hippodrome could accommodate 1,250 patrons, and was intended to house circuses, variety acts and films. However, audience numbers were disappointing. Its owner, T. G. Transfield, could not make the Hippodrome pay, and sold the venue in 1906. It had a number of owners before the Chatham, Rochester and District Rink Co. purchased the building and converted it for roller-skating.

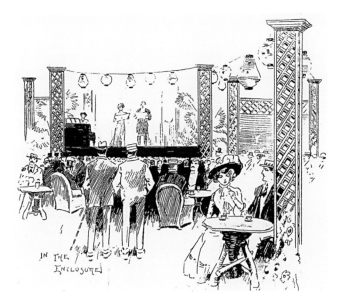

Hippodrome

The rink did not pay either and a circus was briefly reintroduced in 1913. Trade exhibitions, flower shows, religious and political meetings followed. During the First World War, the army commandeered the deteriorating jinxed structure as a training and social centre. By the end of the war, the Hippodrome was a ramshackle and empty shell. It was demolished in the early 1920s. The site is now covered by Balmoral Gardens and a health centre.

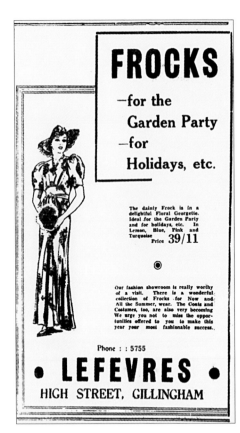

FROCKS

—for the
Garden Party
—for
Holidays, etc.

The dainty Frock is in a
delightful Floral Georgette.
Ideal for the Garden Party
and for holidays, etc. In
Lemon, Blue, Pink and
Turquoise. Price **39/11**

◉

Our fashion showroom is really worthy
of a visit. There is a wonderful
collection of Frocks for Now and
All the Summer, wear. The Coats and
Costumes, too, are also very becoming.
We urge you not to miss the oppor-
tunities offered to you to make this
year your most fashionable success.

Phone : : 5755

● LEFEVRES ●

HIGH STREET, GILLINGHAM

Left: Lefevre's Department Store, High Street
In 1896, impressed by the numbers of prams being
wheeled around, Mr and Mrs Saunders opened a baby
linen shop. By 1909, the business had evolved into
a general drapery, Lefevre's. Mrs Saunders was the
former Lucy Lefevre, a Canterbury draper's daughter.
By the late 1930s, Lefevre's occupied the entire High
Street/Gardiner Street corner. The company was
acquired by Debenhams in 1938, but continued to
trade under its original name. It did not survive the
economic recession of the 1980s.

Below: The Burnt Oak
Many of New Brompton's streets were built with
pubs on their corners. In Victorian developments
such as these, the pubs were often the first buildings
to be constructed. Building workers were paid there
on Saturday afternoons and would hopefully spend
much of their wages on drink. This example, on
the corner of Gardiner and Saunders Streets, was
probably named after Burnt Oak Farm, created in
the 1820s on former woodland.

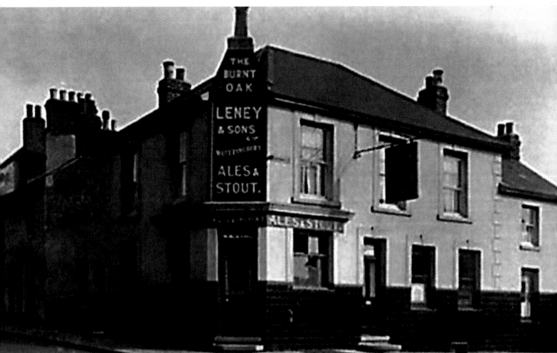

Gem Cinema and Variety Theatre
In January 1910, the first cinema in the Medway Towns was opened by the local entrepreneurs Coley and Sidney Goodman. Modest by later standards, the venue accommodated a few hundred patrons. It was situated in the former Victoria Hall in King Street. The Goodmans sold the Gem in 1922. The cinema survived as the King's Hall, until its interior was destroyed by fire in 1935. The building had a variety of uses before it was demolished in the 1980s to make way for housing.

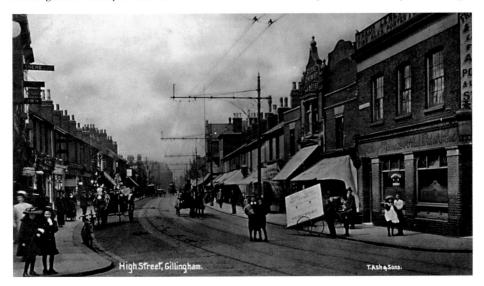

Gillingham High Street – East End
This Edwardian photograph was taken from the High Street's junction with Victoria Bridge and Victoria Street. On the right is the Railway Hotel, although the station itself was then some distance away, in Railway Street. The shop beyond this pub was Henry Tremain's greengrocery. Arthur Stooke, chemist and dentist, occupied the building with the elaborate façade. Next door was a stationer's, and at No. 162 J. Goodwin & Co, pork butchers.

Kingswood Chambers, High Street

When in 1916 this block of shops opened at the corner of Victoria Street, it was advertised as 'The Shopping Centre of Gillingham'. A. E. Clifford, the estate agent, took offices in the complex. By 1919, another of Clifford's concerns, the Gillingham Cycle Co., had taken Nos 172–176. By 1923, the Rochester, Chatham & Gillingham Gas Co.'s showrooms and offices were on the premises. At the time of writing, much of Kingswood Chambers is disused, the only occupant being a pharmacy.

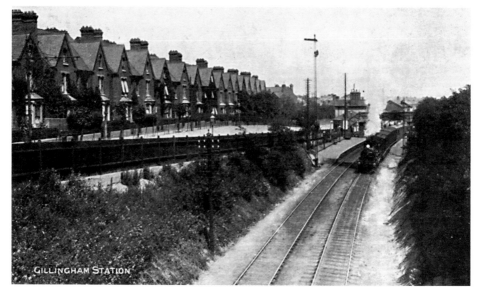

New Brompton Railway Station

When the East Kent Railway opened its line from Chatham to Faversham in 1858, a station was built in fields at the edge of New Brompton. Named after this growing township, this facility also served Brompton and Gillingham village. Its buildings were in what is now Railway Street. Photographed after the single-track line had been dualed, the train is on the up line to London.

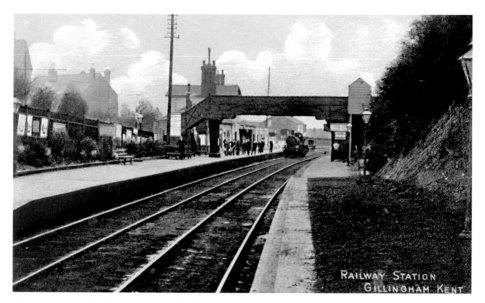

New Brompton Railway Station – Criticisms

The expansion of the dockyard had attracted thousands of new residents to New Brompton. By 1899, eight wagonloads of goods for shopkeepers arrived daily, but the station only had facilities for handling two. A wooden footbridge, from what was to become Balmoral Road, had enabled passengers to walk to the station from the south. After the opening of Victoria Bridge linking Balmoral Road with the High Street, the footbridge closed. Now passengers had to make a diversion of hundreds of yards.

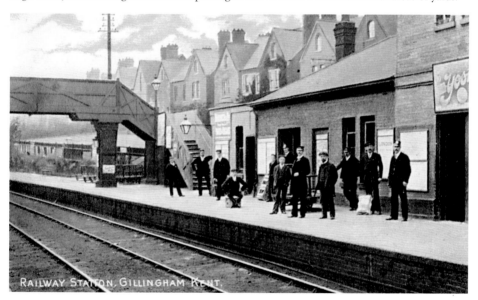

New Brompton Railway Station – Improvements

In 1899, a deputation, including members of the District Council and the Chamber of Commerce, put the case for a new station to the recently formed South Eastern and Chatham Railway. Additional criticisms included the fact that WHSmiths' bookstall took up half of the booking hall. On wet days, only a third of the passengers could find shelter. Although the company made some improvements, it took a further thirty years for a new facility to be built on Victoria Bridge.

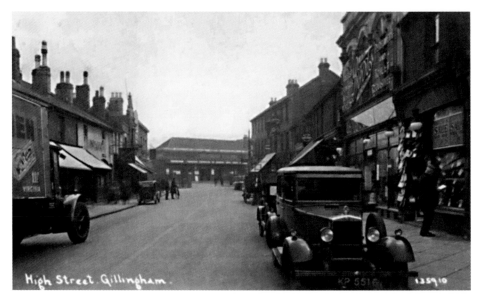

High Street, East End

The new Gillingham railway station that opened in 1932 lies in the background. On the left, Stookes' Pharmacy has been taken over by J. P. Miller and Sons. The lorry may be delivering goods to Mrs Steele's tobacconist's shop. The driver of the magnificent car on the right has possibly called in to Jasper & Sons' bakers shop. Next door is the Cash Boot Co. The large building beyond it housed Boots the Chemist.

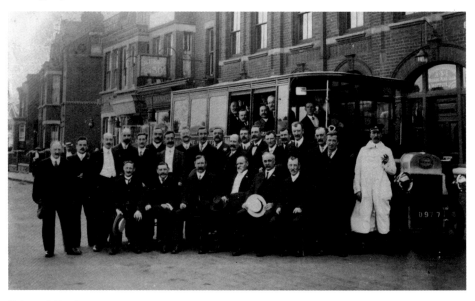

Balmoral Road

These smartly dressed gents, presumably trade unionists, about to embark on a charabanc trip, are posing near Victoria Bridge. Behind them is the Borough of Gillingham Amalgamated Society of Engineers Workmen's Club and Institute. Beyond the Maidstone and District Bus are the premises of Sidney Bramwell (tailor), Alfred Spenceley (builder) and William Safferey (dentist). These buildings still stand and Gillingham railway station now lies opposite.

Right: A. E. Clifford
This distinctive building at No. 43 Balmoral
Road housed the offices of A. E. Clifford, the
auctioneer, valuer and estate agent. The firm shared
the building with Bassett and Boucher, a firm of
solicitors. In 1916, Cliffords moved to Kingswood
Chambers at Nos 172 – 176 High Street, leaving
Bassett and Boucher sole occupants of the Balmoral
Road premises. This building is long gone.

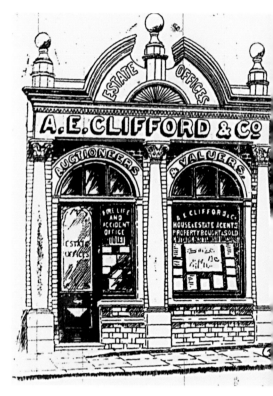

Below: St Barnabas Church
As New Brompton spread southwards, new places
of worship were required. St Barnabas Mission
Room opened in Trafalgar Street in 1886. Its move
to larger premises in Stopford Road soon became
inadequate too. Thus when St Barnabas opened
at the junction of Nelson, Seaview and Stopford
Roads in 1890, it could accommodate more than
500 worshippers. It was built in red brick by
Charles Skinner, the Chatham builder. At the time
of writing the future of St Barnabas is uncertain.

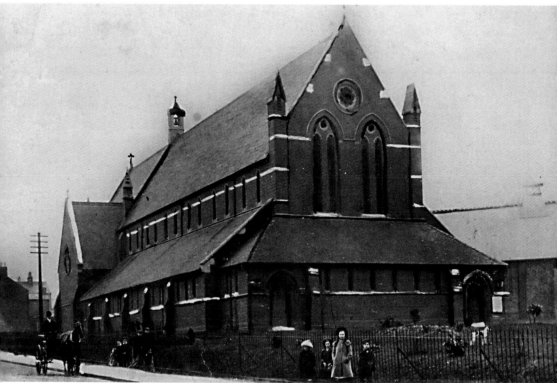

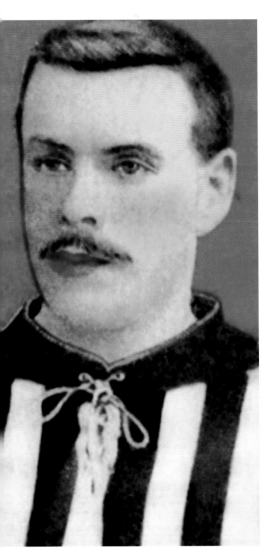

Left: Steve Smith
This experienced footballer had played outside
left for Aston Villa and Portsmouth before joining
Gillingham Football Club (then named New
Brompton) in 1906. Smith was player-manager
during the next two seasons. In that time he made
nearly eighty League and FA Cup appearances, and
scored five goals. Gillingham was his last club as
a professional player. He retired at the end of the
1907/08 season.

Below: Grandstand – Gillingham Football Club
This drawing of the brand new stand was made
in November 1914. A matter of weeks later,
storm-force winds blew the roof off, twisting girders
out of shape as it did so. The rebuilding of the
structure was not completed until March 1915.

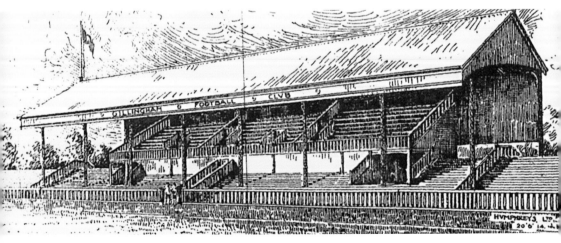

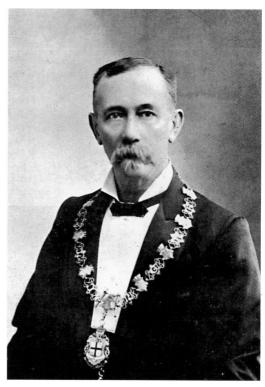

Right: Alderman John Robert Featherby
It is little wonder that Featherby has a road named after him. On Gillingham's incorporation in 1903, he was chosen as the borough's first mayor. Featherby's business activities were remarkable. He ran the brick making and horticultural concerns founded by his father. He was on the boards of Leavey's, the Chatham outfitters, the Chatham and District Laundry Co. and the Gillingham Portland Cement Co. He was a Rochester Bridge warden, chair of the Nursing Association of Gillingham and a magistrate. Featherby died at the age of seventy-four in 1922.

Below: Incorporation, 1903
On 9 September 1903, a group of dignitaries from Gillingham travelled to London to collect the Charter of Incorporation. The party included C. T. Smith, the High Constable, the provisional mayor J. R. Featherby and urban district councillors. On their return they were joined by Sir Horatio Davies, MP. The charter was read for the first time at the corner of Railway Street and Kingswood Road.

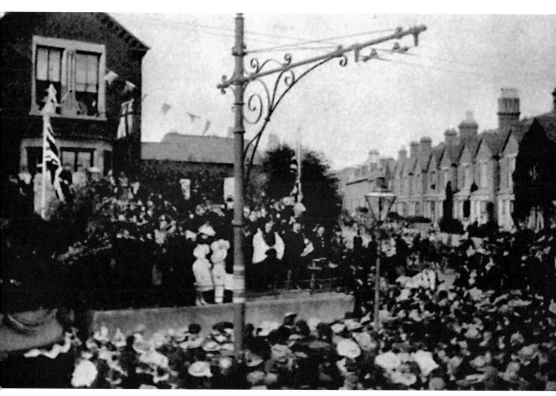

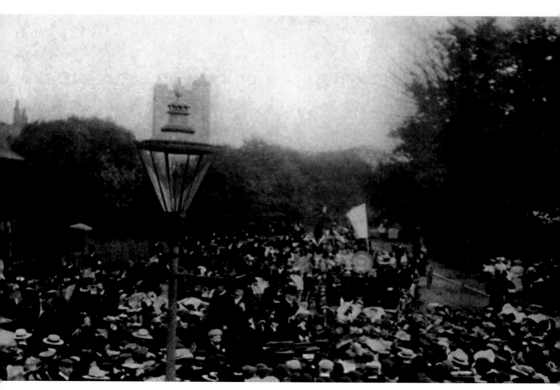

Incorporation
After the National Anthem was sung, the party moved on, repeating the process at various points in the new Borough. This picture shows the scene at Gillingham Church. The procession terminated at the recently purchased site which would be transformed into Gillingham Park a few years later.

New Borough of Gillingham

Convent of St Chretienne, Corner of Franklin and Gillingham Roads
This 'Convent School for Young Ladies' opened in 1903. The Order of St Chretienne had three other schools, including one in Strood. The Gillingham school was staffed by French nuns, the principal being Sister Cecile. The 1911 census reveals that most of the scores of boarders were French, although it also took Catholic day students. The girls were prepared for examinations for the Associated Boards of the Royal Academy and Royal College of Music. Shorthand was taught along with English as a foreign language.

Convent of St Chretienne – Continued

In 1909, tragedy struck when Sister Lucy, one of the nuns, was killed in an accident. She was busy washing blouses in benzolene, in a workroom near the entrance to the convent, when the vapour ignited. Sister Lucy and a local needle woman, Agnes McCully, escaped, but the nun re-entered the building to rescue a basket of linen. The door slammed shut and she was overcome by fumes. Her charred body was pulled out by two local passers-by.

Convent of St Chretienne – War and Closure

During September 1914, the convent was used as a billet for new army recruits and as a temporary home for Belgian refugees. In late 1920, the nuns at Gillingham were recalled to France. In 1923, the building reopened as a Masonic temple. It has now reverted to religious use as the Kent Ramgarhia Darbar Sikh Temple.

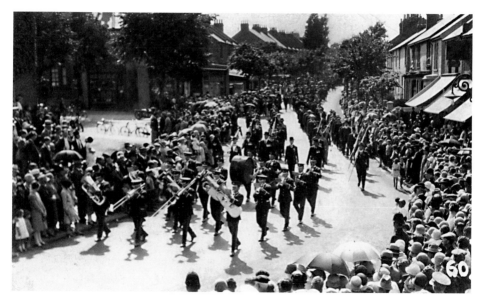

Livingstone Circus

We are fairly sure that this picture was taken in the Livingstone Circus area. The tree foliage and use of umbrellas in dry, sunny conditions would indicate that this is a summer scene. The hats of the women probably put the scene in the 1920s. However, we cannot identify the occasion. The band does not appear to be military, but the bowler-hatted men behind it are wearing medals. We would welcome readers' suggestions as to the date and occasion of this procession.

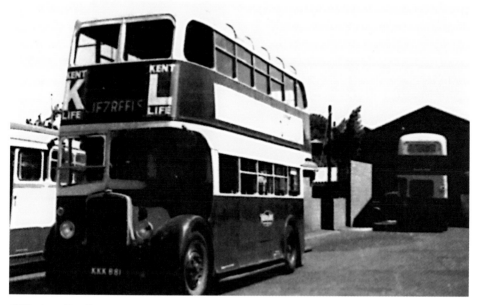

Gillingham Bus Depot

This Bristol double-decker is pictured at the Maidstone and District depot in Nelson Road in 1962. One of the company's Guy double-deckers is parked behind it. Notice the destination shown on the Bristol's blind; the Jezreel's Tower had been demolished the year before, but the general area had taken its name.

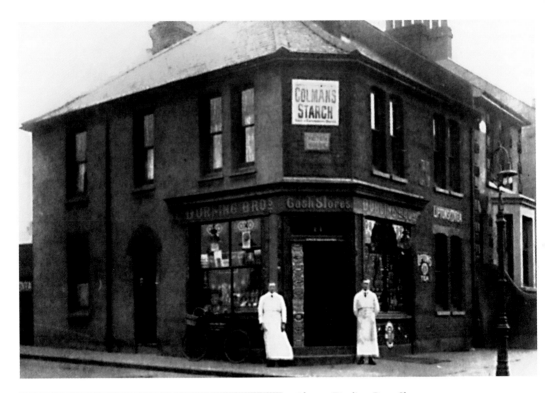

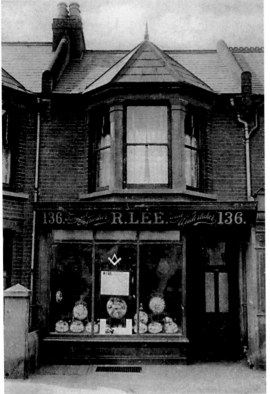

Above: Durling Bros Shop

These premises, on the corner of Stopford and Seaview Roads, were used as a grocer for many years. The brothers Charles and Ernest Durling took over the business from Percy Sutton in 1912. Eventually Ernest conducted the business alone, until he sold it to the Farr brothers in 1936. In the 1950s, the shop was home to Halliday and Rogers. It survived as a grocery at least until the 1970s.

Left: Robert Lee & Son, Richmond Road

Originally a general shop run by Albert Pope, it was taken over by Robert Lee in 1905 and converted into an undertaker. By 1911, Lee had opened a monumental mason's business nearby and had been joined by his son. In the mid-1920s, the monumental mason's business closed, but the Richmond Road shop survived for another ten years. When the undertaker concerned ceased trading, members of the family continued to live on the premises. The shop is now a Chinese takeaway.

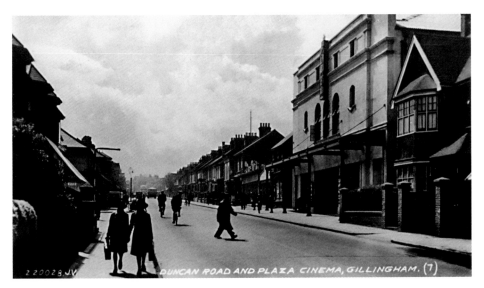

Plaza Cinema

In 1929, the Croneen brothers purchased a site in Duncan Road opposite its junction with Franklin Road. They then sold their Invicta cinemas in Chatham and Strood and rented out the Gillingham Invicta. This financed the construction of the Plaza – the first purpose-built cinema in the Medway Towns for talking pictures. More than 1,800 filmgoers could be seated in what was then the most modern cinema in the area.

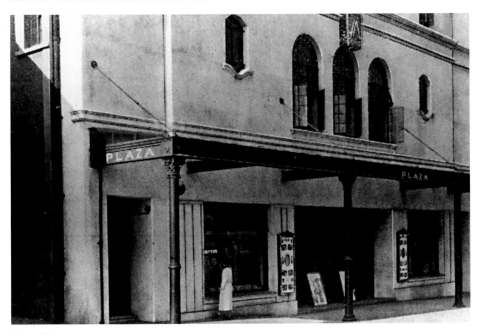

Plaza Cinema

Within a few years, the large national syndicates, such as Gaumont British and Odeon, built luxurious 'super cinemas' in the area. The Plaza soon seemed outdated. It eventually specialised in showing second-run films. The venue remained in the hands of the Croneen family until its closure in 1980. A supermarket now occupies the site.

Left: Opening of the Royal Naval Hospital, 26 July 1905
At noon, King Edward VII arrived at Rochester railway station. He was driven through the streets of Rochester and Chatham to Brompton, where he unveiled the South African memorial. After lunch, he journeyed to the newly built Royal Naval Hospital in New Brompton. The assembled guests heard cheering long before the King arrived. After brief prayers and a psalm sung by the Dockyard Church Choir, Edward was given a gold key by Inspector-Gen. Adm. Pollard RN. The King then opened the huge main doors.

Below: Opening of the Royal Naval Hospital
The King was escorted round part of the hospital. He visited the dayrooms, operating theatre, offices, men's wards and the kitchen. Having fulfilled these duties, the King was driven back to the railway station. He is seen here leaving the site through the hospital's impressive gateway.

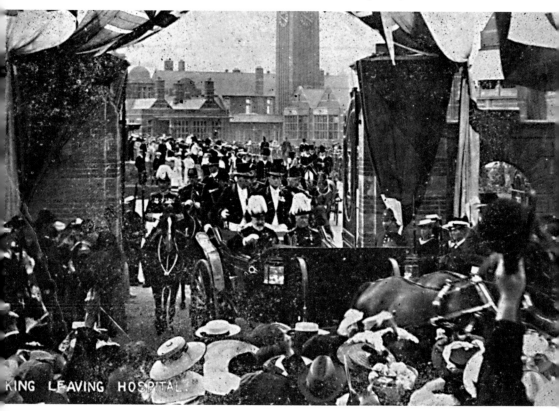

KING LEAVING HOSPITAL

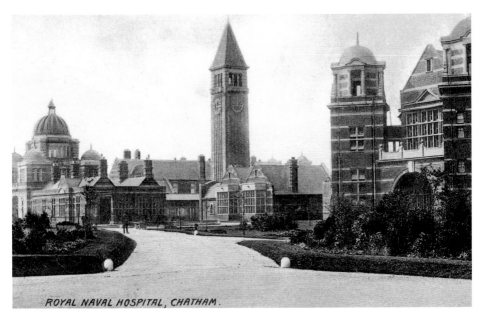

Royal Naval Hospital

The hospital area covered around 20 acres. It consisted of a range of red-brick buildings with stone dressings. At the time, they were described as having an almost Byzantine appearance. There were effectively two infirmaries on the same site. As well as the main infirmary, there was also a self-contained zymotic hospital.

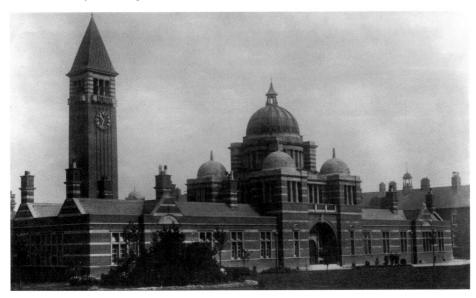

Royal Naval Hospital – Design

The main hospital was designed on what was called the pavilion principle. All the pavilions were linked to the operating theatres, dispensary and so on via a corridor. The central pavilion, shown here, was surmounted by a large dome, flanked by four smaller ones. The administrative block contained the boardroom and offices as well as ophthalmic and x-ray departments. The first floor housed a pathological museum and a medical library.

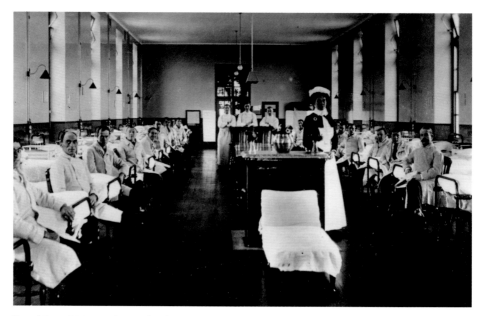

Royal Naval Hospital – Medical Ward

The wards in the main hospital could accommodate a total of 468 patients. Those in the zymotic building housed more than 100. The large wards were light and airy. The floors were of polished teak and the cemented walls were painted in green or buff.

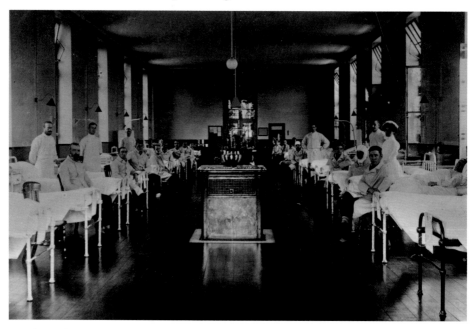

Royal Naval Hospital – Surgical Ward

Notice the electric lighting and centrally placed heater in this immaculately polished ward. The male sick-berth attendants, such as those posing in this picture, lived in two large barrack rooms complete with kitchens and recreational mess rooms. The Royal Navy relinquished its hospital in 1961. Many of its buildings now form part of the Medway Maritime Hospital.

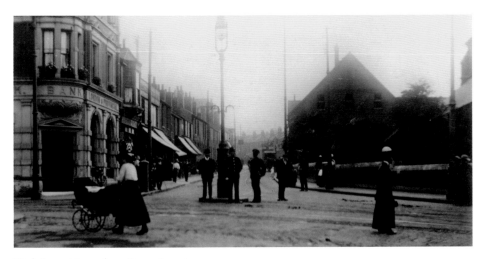

High Street/Canterbury Street Junction
The Edwardian photographer was standing at the junction of Skinner Street and High Street when he recorded this scene – a dangerous undertaking today. The wall surrounding St Mark's church is on the right, and the London and Provincial Bank is on the left. Behind the policeman, winding its way towards the London–Dover Road, is Canterbury Street. Apart from the lamp in the middle and a woman nonchalantly wandering through the thoroughfare, this view has remained virtually unchanged over the last 100 years.

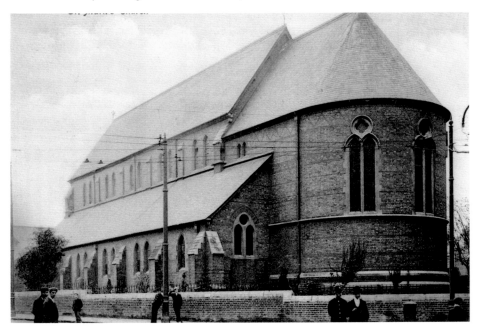

St Mark's Church
New Brompton's expansion required additional church building. A new parish of St Mark was created, whose church was consecrated in 1866. This imposing structure, on the corner of High Street and Canterbury Street, was of yellow brick with bath stone dressings. It could accommodate 800 worshippers. As designed by J. P. St Aubyn, this church was originally intended to have a tower complete with a spire. This never materialised. St Mark's continues to be a place of worship.

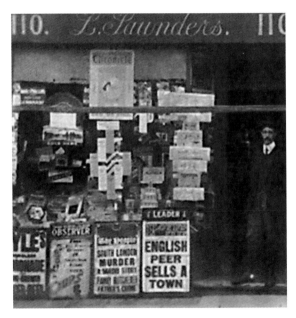

Saunders' Tobacconist
Intriguing placards immediately attract the eye in this scene of an Edwardian tobacconist and newsagent's shop. The man standing in the doorway is likely to be Lancelot Saunders, the shop's owner. He was in business for around 10 years at these premises, which lay in Canterbury Street between Lawrence Street and Copenhagen Road. By the end of the First World War, Saunders had moved round the corner into Copenhagen Road, where he had become a printer.

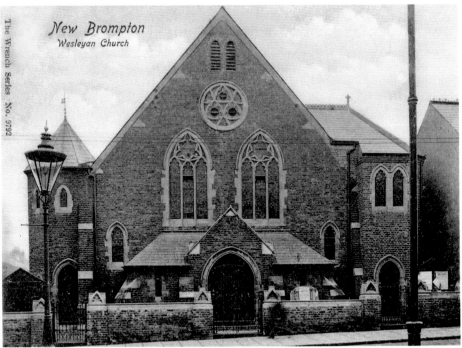

Wesleyan Church, Canterbury Street
This chapel opened in 1882, on land previously part of Westcourt Farm. It was situated on the corner of Green Street near the Baptist Tabernacle. The Gothic brick structure accommodated 600 worshippers. Before the Second World War, the Wesleyans united with the other Methodist groups. As religious worship declined, the church became redundant and closed in 1963. The congregation then merged with that of the Jubilee church in Trafalgar Street. The Canterbury Street chapel was demolished a few years later. Offices now occupy the site.

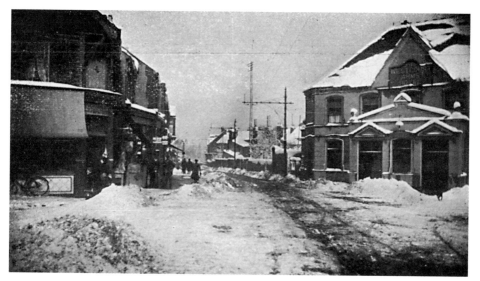

Week of Snow – Canterbury Street, March 1909

The cold weather struck over a weekend, relented, then returned with a vengeance. On Tuesday, 9 inches fell overnight. Trams were run to keep the tracks clear, but the lines were blocked anyway by Thursday. New Brompton's football match against Leyton Orient was postponed and schools were closed. Apart from schoolchildren, the only beneficiaries from this cold snap were the unemployed. Hundreds of them got work clearing snow and picking up heaps of collapsed guttering.

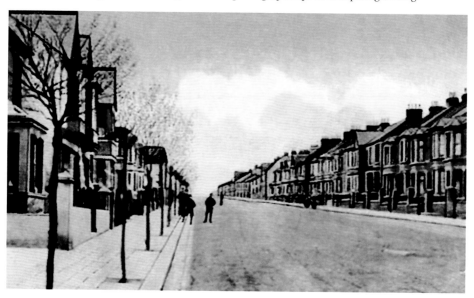

Rock Avenue

Much of the expansion of New Brompton was due to the activities of land companies. Farm land was purchased, cleared, levelled, divided into plots and sold to builders, speculators and individuals. In 1884, the Rock Land Society purchased a large estate in New Brompton, between what are now Windmill Road and Canterbury Street. Many of the resulting streets were named after notable poets. Rock Avenue was an unusually wide thoroughfare of superior housing, which bisected the new development.

Left: Working Men's Club – Rock Avenue
This social club started life in 1881 as the Old and New Brompton Working Men's Club. It was then situated in New Brompton High Street, near St Mark's church. In 1904, it relocated to its present position at the junction of Rock Avenue and Canterbury Street. The club as seen here is decorated to celebrate the end of the First World War.

Below: Jubilee Bible Christian Church – Trafalgar Street, 1887
The Bible Christian branch of Methodism was strong locally. The Jubilee church, built by Charles Skinner and designed by William Margetts, was of red and white bricks. It replaced a smaller chapel in Park Road, and could seat 350 worshippers. By the 1960s, Methodism was in decline and the Jubilee and Canterbury Street congregations joined forces to form St Peter's. The front of the Jubilee church was removed and replaced by a blue, yellow and white façade, with wide glass panels.

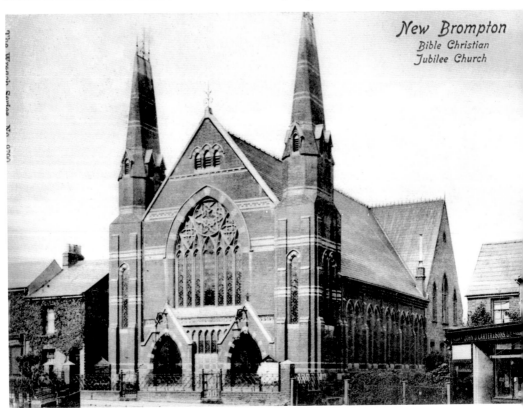

New Brompton
Bible Christian
Jubilee Church

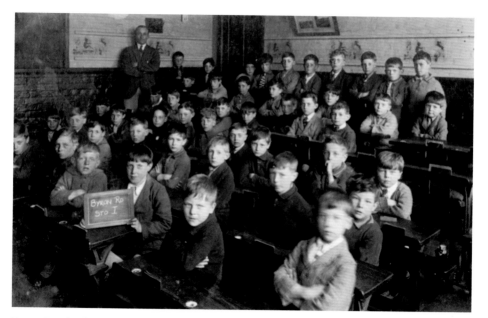

Byron Road School

Today's primary schoolchildren wear sweatshirts complete with corporate logos. In the 1920s, when this photograph was taken, children wore whatever their parents could afford. This is a Standard One class at Byron Road School off Canterbury Street. It dates from a time when boys and girls of this age were educated separately. The school itself had been opened in 1896.

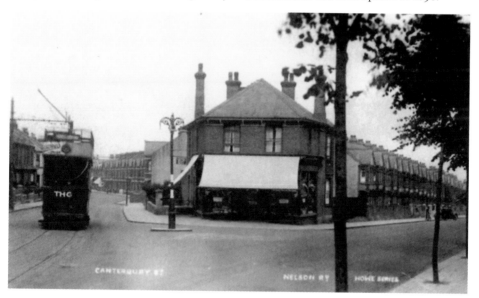

Canterbury Street/Nelson Road Junction

Some time in the 1920s, this photographer was standing outside Gillingham Park. The tram was on its way to Chatham Town Hall, from the Shalders Arms terminus on the corner of Richmond and Medway roads. The row of houses at the top of Nelson Road may still be seen as may the buildings in Canterbury Street behind the tram. The confectioner's, owned by David Rogers and passed to William Walden around 1927, is no more. A different building now stands there.

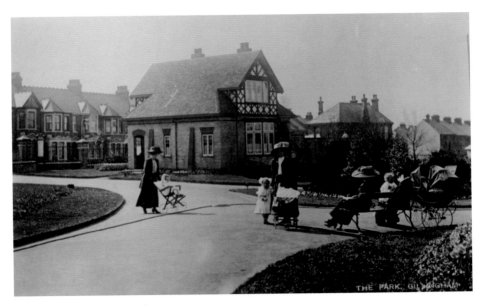

Creation of Gillingham Park

In 1903, Gillingham Urban District Council decided to create a park. Disagreement ensued as to whether the site should be close to the working people or in the up and coming south of the town, at the top of Canterbury Street. The latter argument prevailed and 16 acres were purchased for £4,800 from Brasenose College, Oxford. Additional expenditure included compensation paid to the existing tenant Richard Sheepwash, legal fees and the cost of laying out the park and building access roads.

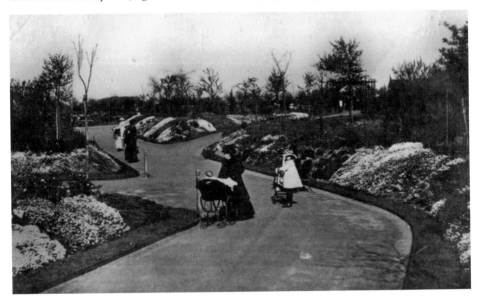

Gillingham Park – Controversies Before Opening

Many non-conformists strongly believed that the Sabbath would be desecrated if so-called 'continental Sundays' were allowed to develop. They urged a ban on refreshments and music in the park on Sundays. Children should also be forbidden from playing there on the Lord's Day. Some people feared that fever may spread from the adjacent infectious diseases hospital. Both groups lost their arguments and the opening ceremony took place in July 1906.

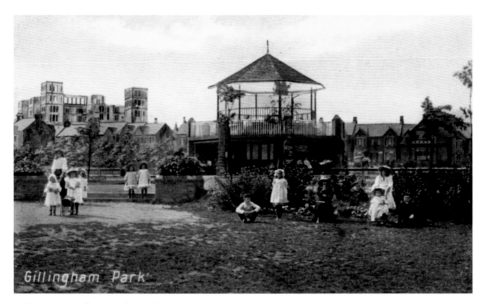

Gillingham Park – Band Stand
Some councillors objected that equipping the park with the band stand was too costly. However, Councillor Crowe won the dispute: 'We might as well build a town hall without a roof as have a recreation ground without a band stand.' The octagonal building of red brick with a red tiled roof contained a ground floor cafe. Bands played on the floor above, with a balcony enabling visitors to walk round the entire circumference. Notice the Jezreel's Tower in the background.

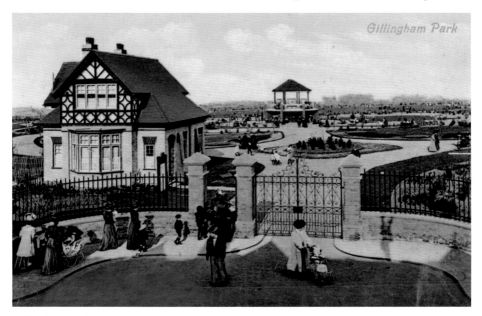

Gillingham Park – Gardener's Lodge
It is clear from this view that the park had only recently been planted. The lodge came rent-free to the resident gardener, who was paid 30s a week. The house was built of white Aylesford brick with a half timbered gable. It now has other uses. The attractive main entrance to the park was later altered for road widening.

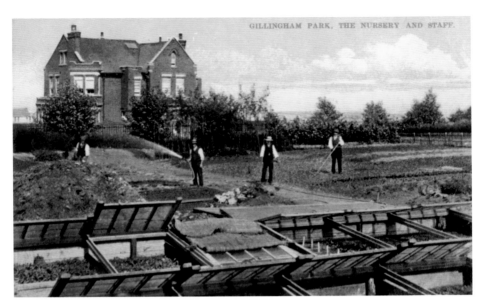

Gillingham Park – Nursery

The men posing in the middle ground are some of the team working for the resident gardener. When the park opened, it was planted with trees, which included lime, plane, poplar, beech and holly, together with flowerbeds and flowering shrubs. It all added to the pleasure of walking the many paths that criss-crossed the park.

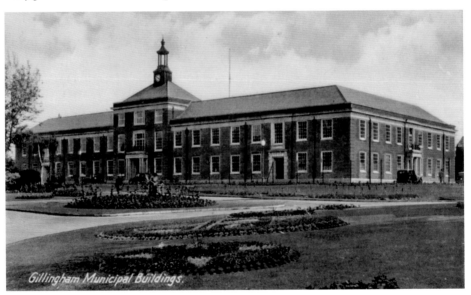

Gillingham Municipal Buildings.

Municipal Buildings

In 1937 Gillingham Council's offices were moved from Gardiner Street to Gillingham Park. The neo-Georgian buildings were constructed of rose-coloured Bexhill bricks. They surrounded two quadrangles divided by the civic suite in the centre. The latter contained the council chamber, committee rooms and mayor's parlour. The complex also housed the town clerks, treasurers, health, education and borough surveyors. It was the surveyor himself, John Redfern, who designed the buildings. A nursing home now occupies the site.

Right: The Jezreelites (the New and Latter House of Israel)

James Jershom Jezreel (James Rowland White) believed in the teachings of the long-deceased Joanna Southcott. She had declared that the coming of Shiloh, the second Christ, was imminent, and that only 144,000 believers would survive when the world ended. Jezreel, claiming to be God's Messenger, formed a sect and wrote a volume of prophecies – The Flying Roll. Gillingham people believed that Jezreel's projected temple was planned to reach the sky. This architectural drawing reveals more limited ambitions.

Below: The Jezreelites' Temple – Exterior

The Jezreelites purchased land on Chatham Hill – one of the highest points in the Medway Towns – and plans were drawn up for an imposing temple. This would serve as both a meeting place and a refuge during the chaos preceding the coming of Shiloh. Jezreel died in 1885 before construction began. The temple was never finished, and the picture shows it in its partly abandoned state. Notice the motifs, including the Prince of Wales feathers, representing the Trinity.

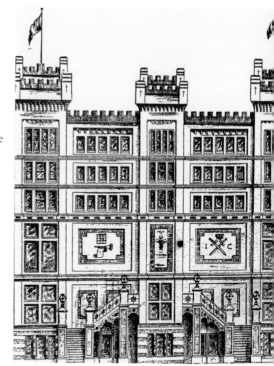

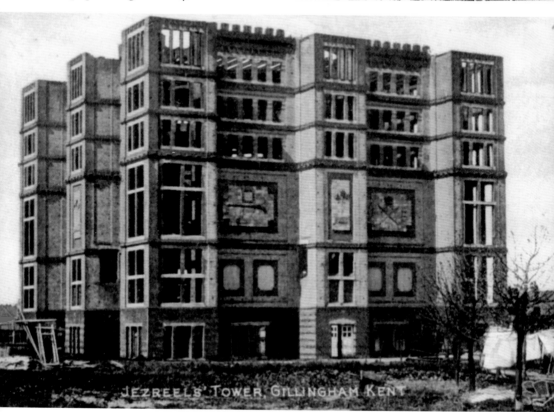

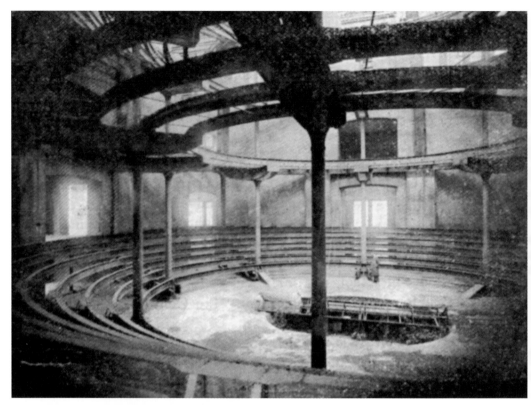

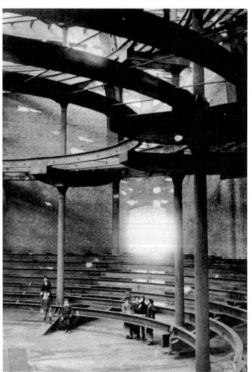

Above: The Jezreelites' Temple – Interior
Jezreel had married Clarissa Rogers, a member
of a local Southcottian family. After her
husband's death, Clarissa took over the sect.
Sceptical local people nicknamed her 'Queen
Esther', mocking what became her increasingly
ostentatious lifestyle. The building of the temple
continued. Notice the circular amphitheatre
that dominated the temple's interior.

Left: The Jezreelites' Temple – Interior, Detail
A platform, which could be hydraulically raised
30 feet above floor level, was placed in the
centre of the amphitheatre. This would enable
all worshippers to see and hear preachers and
listen to the sect's locally renowned choirs. The
temple could accommodate up to 5,000 people,
although nowhere near this number was ever
reached.

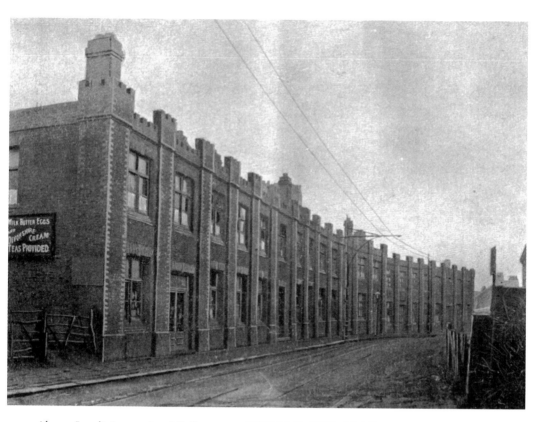

Above: Israel's International College
In addition to their temple, the Jezreelites built a two-storey block of buildings facing Canterbury Street. This was planned to be 'Israel's International College'. Its aim would be to propagate the sect's teachings and train preachers and evangelists. However, after 'Queen Esther's' death in 1888, the number of followers declined dramatically and the movement was riven by leadership struggles. Sales particulars of 1913 reveal that, by then, the college housed shops, living accommodation and even a dancing academy.

Right: The Jezreelites' Trades
In its heyday, the New and Latter House of Israel attracted converts from around the United Kingdom and beyond. Most gave their wealth and possessions to the sect. The Jezreelites supported themselves by various business concerns, some based near the temple and others in New Brompton High Street and Luton Road in Chatham.

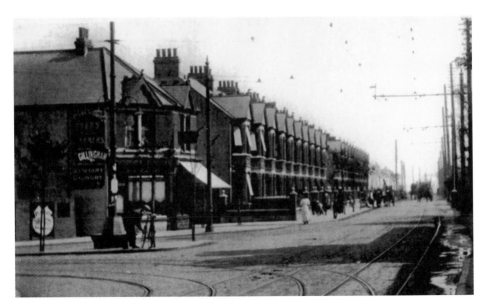

Junction of Watling Street and Canterbury Street, *c.* 1910
All these buildings had been constructed within the previous few years. The row of Edwardian villas remains a familiar sight today. The shops on the left consisted of a receiving office of the Clarence Sanitary Laundry and the premises of William Grist, tobacconist and confectioner. Within two years, Grist's widow Isabella ran the business, and the laundry had been replaced by a butcher. Watling Street was widened between the wars and a new row of shops was erected on the right.

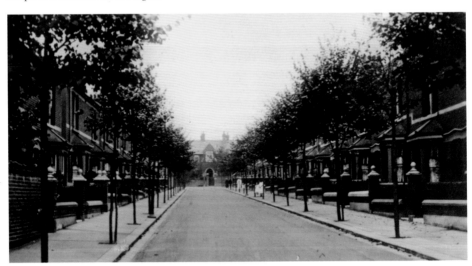

Park Estate – Chester Road
During the Edwardian period, Gillingham spread southwards towards its border with Chatham. Developments for the lower middle class sprang up rapidly as the new trams enabled people to move out of the overcrowded town centres. These included the Park Estate, on high ground south of Gillingham Park and east of Canterbury Street. The estate's advertising proclaimed it to be a 'Health Resort ... The residents above Gillingham's "municipal lung" are guaranteed by the immutable law of gravitation an inexhaustible supply of the purest air.'

Right: Park Estate – Holmside

Aimed at readers experiencing the hot dry summer of 1906, the Park Estate's advertising stressed its elevated position: 'No matter how hot, thirsty, perspiring a man may be, when he reaches a certain tree-lined roadway whence a lovely view of the Medway can be obtained, his cheek is fanned by a gentle breeze as cool, as pleasant and as revivifying as only a whiff of the real salt sea can be ... The air is not only more pure, but more stimulating than in any other part of the town.'

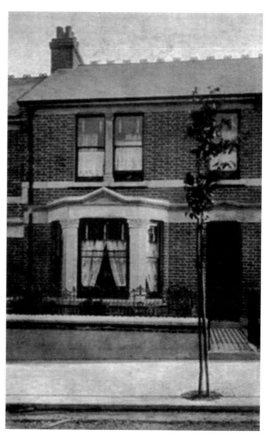

Below: County School for Boys, Third Avenue

A selective boys' school for Gillingham was discussed before the First World War. However, the plans were shelved due to fears that the Rochester Mathematical School would be damaged if it lost its Gillingham pupils. The project was revived after the war, with the school opening in 1923. It was a single-storey building set in 10 acres of playing fields. Parents paid fees, although Kent County Council provided twelve free scholarships, and Gillingham Council a further eighteen half-fee places.

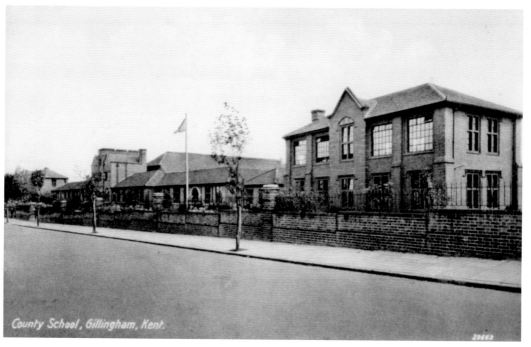

County School, Gillingham, Kent.

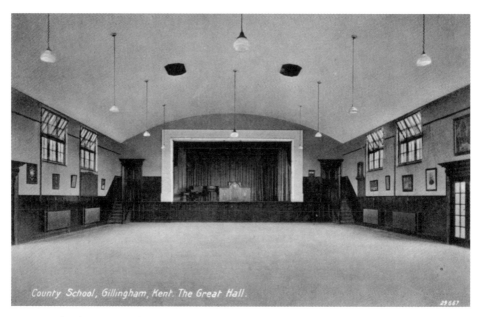

County School – Great Hall

Post-war spending cuts meant that the school was half the planned size and always inadequate for Gillingham's needs. In 1927, the building was greatly expanded, enabling the school to double the number of students to 400. The most prominent feature of the new premises was the light and airy assembly hall, which could accommodate 800 people. The stage was suitable for drama and concerts.

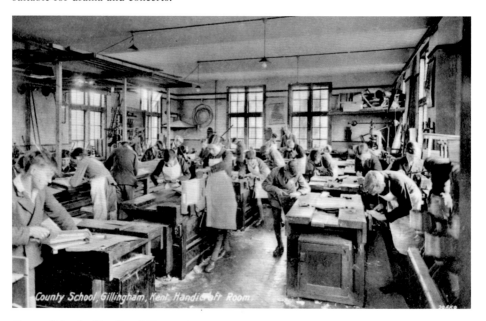

County School – Handicraft Room

The subjects taught in this facility included woodwork and electronics. When a *Chatham News* reporter visited in June 1927, pupils were making copies of an electric clock from an original built by their teacher, Mr Kingsley. Other pupils were constructing tubular bells.

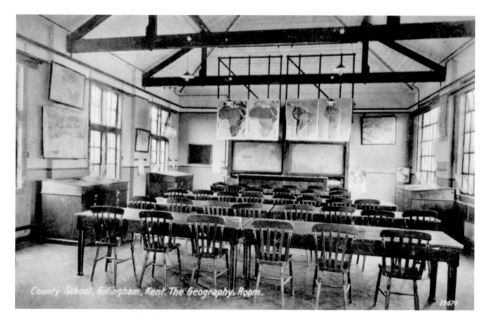

County School – Geography Room

The *Chatham News* reporter was impressed by relief maps created by pupils from flour and salt. This room also housed a geographical 'museum', which contained rocks, fossils and historic maps.

After the Education Act of 1944, the County School became Gillingham Grammar School for Boys. The buildings have since evolved into the Robert Napier School.

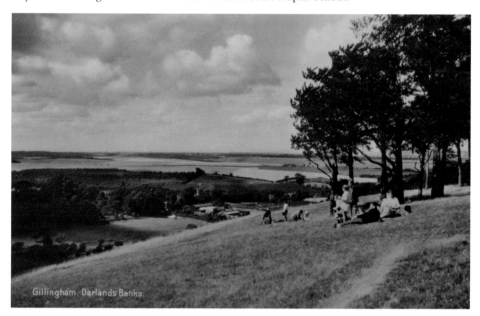

Darland Banks

The War Department owned this grassy escarpment, which had been popular with walkers and picnickers for many years. In December 1932, it was due to be sold off by auction. However, Chatham and Gillingham councils were keen to buy it, and sent a joint deputation to lobby the government. The two councils were successful, purchasing 68 acres shared equally between them.

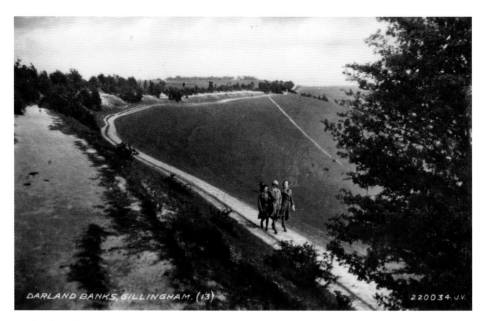

Darland Banks
This inter-war photograph captures three women walking towards the Chatham section of the banks from the Gillingham end. The banks have always been home to many rare species of flora and fauna. The entire 112-acre site is now managed by the Kent Wildlife Trust.

Star Public House
Dating from at least the eighteenth century, this pub stood isolated in farmland adjoining the London to Dover Road. On high ground, away from the dirt and smoke of Chatham and with uninterrupted views of the River Medway, it became a favourite refuge for servicemen and civilian workers. Sports were played in the adjacent fields and political and social groups met inside. In this Edwardian picture, the present-day Darland Avenue is labelled Star Lane and the sign directs travellers to Darland and Hempstead.

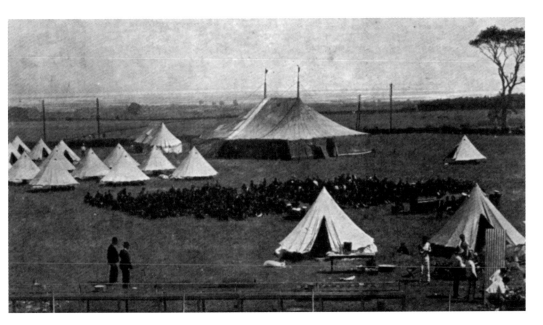

Royal Engineers' Volunteers at Fort Darland, 1904

Annually, parties from the Volunteers, a predecessor of the Territorial Army, used the fields around Fort Darland for a week's camp. In 1904, the 1st Aberdeen RE Volunteers occupied the open ground overlooking the River Medway. The part-time soldiers spent all their time training and there were no drills. Church parades were short and the men stayed in camp for them. The marquee was probably from the Welcome Home for Sailors and Soldiers at Chatham. It provided refreshments and letter writing facilities. The fort became an Army technical school in 1910.

Pleasure Flights

After the First World War, there were attempts to popularise flying. Demonstrations at 'Darland Farm', adjacent to the Star pub, had begun in the mid-1920s. In May 1930, the farm obtained a two-week aerodrome licence, and an 'air-taxi' flew in from the London Air Park at Hornchurch. This small black and orange aircraft could take two passengers on a short flight at 5s each. Work on building the Darland housing estate began the following year, forcing these annual flying events to cease.

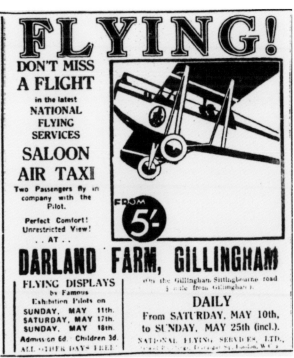

FLYING!

DON'T MISS A FLIGHT

in the latest NATIONAL FLYING SERVICES

SALOON AIR TAXI

Two Passengers fly in company with the Pilot.

Perfect Comfort! Unrestricted View!

.. AT ..

FROM 5/-

DARLAND FARM, GILLINGHAM

FLYING DISPLAYS
by Famous
Exhibition Pilots on
SUNDAY, MAY 11th.
SATURDAY, MAY 17th.
SUNDAY, MAY 18th.
Admission 6d. Children 3d.
ALL OTHER DAYS FREE

(on the Gillingham, Sittingbourne road
½ mile from Gillingham.)

DAILY

From SATURDAY, MAY 10th.
to SUNDAY, MAY 25th (incl.).

NATIONAL FLYING SERVICES, LTD.,

79

Darland Estate

In 1929, the government sold much of the land surrounding Fort Darland to Alfred Clifford, the Gillingham estate agent. The site was cleared, divided into plots and developed as the Darland Estate, straddling the boundary between Chatham and Gillingham. Much of the estate was built before 1939, the remaining portion not being completed until the 1950s. Fort Darland itself was sold in 1946, and became a mushroom farm until it was purchased by developers who constructed houses on the site.

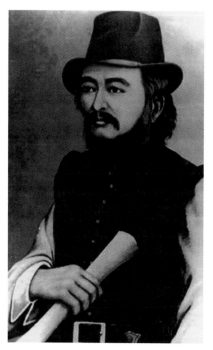

Will Adams

Born in Gillingham in 1564, Adams undertook a twelve-year apprenticeship in shipbuilding and navigation on the Thames. Having gained experience as a pilot on the North African coast, he was pilot major for a Dutch fleet bound for the Far East. Only Adams' ship survived, and he arrived in Kyushu, Japan, in 1600. The Shogun forced the party to stay. Adams educated the ruler and his advisors in European science and shipbuilding techniques. He died in 1620.

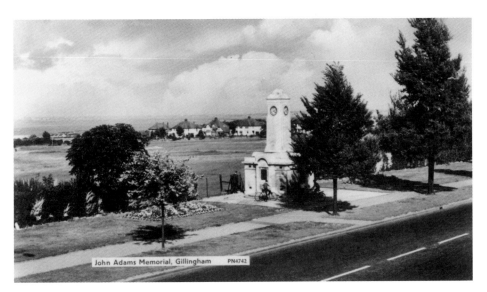

John Adams Memorial, Gillingham PN4742

Will Adams Memorial – Unveiling

One Tuesday afternoon in May 1934, motorists on the London–Dover Road at Gillingham were forced to divert off the road at First Avenue to re-emerge at the top of Woodlands Road. This enabled a party of distinguished visitors, including the Japanese ambassador, to walk in procession from Clifford's Estate Agents on Watling Street to the Will Adams memorial. On their arrival, the Royal Naval Band played the Japanese National Anthem and after appropriate speeches the memorial was unveiled.

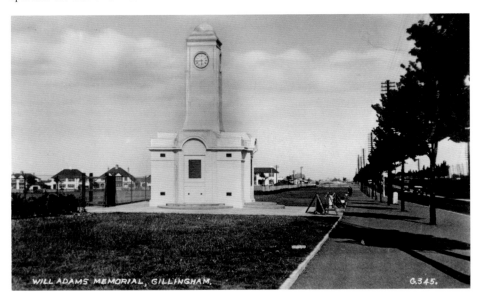

WILL ADAMS MEMORIAL, GILLINGHAM. G.345.

Will Adams Memorial – Description

It consists of a 25 ft-high tower clad in stone, containing a four-faced electric clock. Bronze panels, explaining the memorial's purpose, are fixed on its base. The panel facing Watling Street is surmounted by a ship sailing towards the rising sun. Harry Tingley, of the Medway Guild in Luton, made the panels. The memorial itself was designed by J. L. Redfern, the borough surveyor. It is still a place of pilgrimage for Japanese visitors.

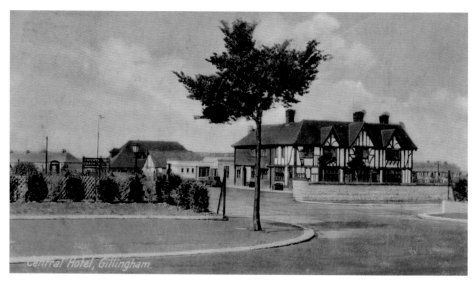

Central Hotel, Watling Street

Motor traffic vastly increased between the wars and, at the time, vehicles travelling between London and the Kent coast went through the Medway Towns. Therefore, in 1934, the enterprising brewers Style & Winch built this roadhouse in the then fashionable mock-Tudor style. Its car park held 200 vehicles, but much of its business came from coach parties. A huge bar accommodated hundreds of customers. In winter it could be dismantled and the space used as a dining area or ballroom. Housing now covers the site.

Amateur Football

The Civil Service Sports Association ground on the Rainham Road provided ideal football facilities. On 5 October 1934, teams from rival drawing offices, probably from the dockyard, played a fixture in the inter-office football cup competition. The team, shown here, comprised, back row, left to right: Thomas, Parker, Freeston, English, Hoskins, Holness, Addicott (referee), Brooker. Seated, left to right: Gilbert, Bate, Ladd, Phillips, Watterworth and Cadman.

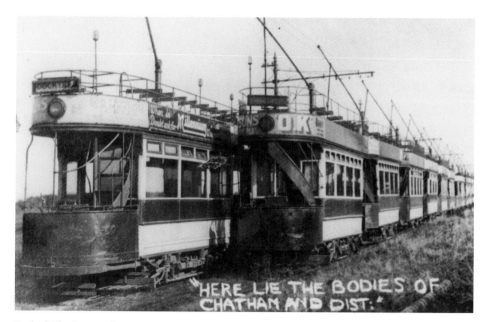

End of Chatham and District Trams, 1930

Tramcar services began in the Medway Towns in 1902. By 1906, one of the routes had reached Rainham via a purpose-built reserve track starting at Barnsole Road. It ran through the open countryside parallel with the main road. Here the trams are parked in this rural section, awaiting disposal, having been replaced by buses.

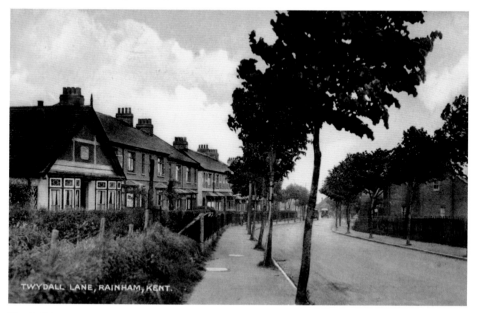

Twydall Lane

These residences, near the junction with Watling Street, are the surviving remnants of the Twydall Garden City Estate. This development, announced in 1908 by Kemp Bros, builders of Rainham, proved to be overambitious and very little of the plans came to fruition. Twydall had to wait for another forty years before large council estates were created on its former farmland.

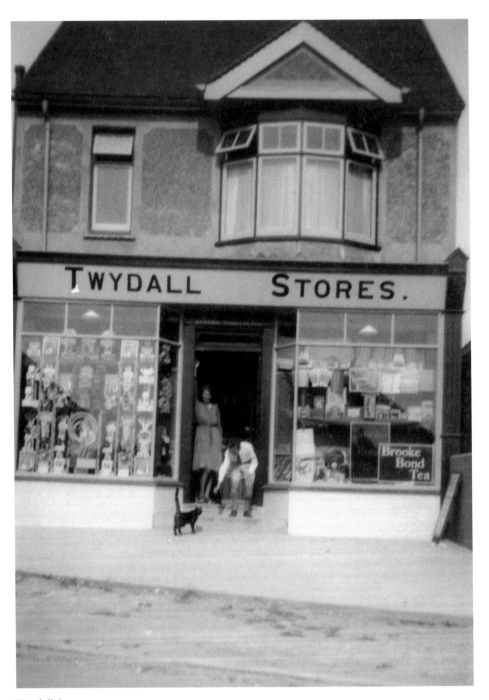

Twydall Stores
This shop first appears in a street directory of 1933. Owned by Harry Rudman, it was situated on the western side of Twydall Lane between The Gables and Brightwell. A little later, Lewis Avenue was cut through between The Gables and Twydall Stores. By 1935, Frank Tabeart owned the shop, which was listed as No. 93 Twydall Lane. The business remained in the Tabeart family for several decades afterwards.

Rainham and Wigmore

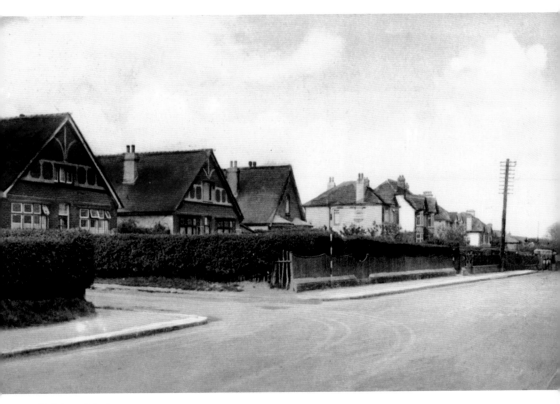

Rainham Mark
'Mark' comes from the Anglo-Saxon *mearc*, meaning boundary. Rainham Mark is at the boundary of Rainham and Gillingham parishes. From 1906, a tram route linked Chatham with Rainham. At 3*d* a journey, commuting was feasible, and Rainham Mark farmland began to give way to housing thanks to the estate agents Harvey & Jelly. Rainham Mark and the village itself had become contiguous by the time this picture was taken.

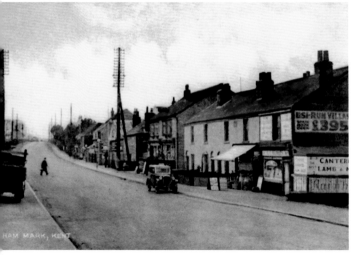

Businesses at Rainham Mark
On the right is the butcher's shop of George Burley, and next to it are the premises of George Russell. Rainham Mark post office and R. G. Hodges' motor garage are beyond Russell's premises. Notice the advertisement for Esi-Run Villas, which were proliferating throughout the Medway Towns in the 1930s.

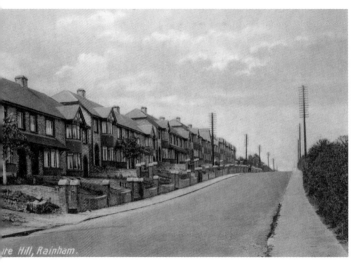

White Hill
This is a classic example of pre-war ribbon development. Newly built homes line the main road between Rainham Mark and Rainham village. Until 1930, trams rattled by, hidden behind the hedge on the right, so the residents were not disturbed. Today's householders would probably prefer the trams' rattle to the constant roar of the road traffic.

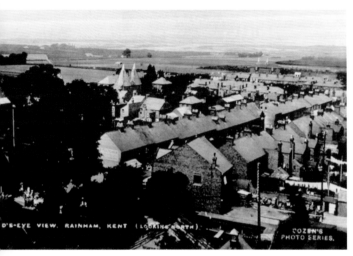

Rainham from the Church Tower
Station Road cuts diagonally across this picture with the River Medway on the horizon. Oast houses and open fields demonstrate that this was still a predominantly rural community. At the time this photograph was taken, Rainham was the western outpost of Milton Urban District Council. By 1929, the village was almost contiguous with Gillingham, whose council absorbed the growing community.

White Horse – Rainham High Street
This pub has a history dating back to
the eighteenth century, and probably
even earlier. It catered for local people
but also for passing stagecoach
travellers on the London to Dover
Road. The former stables may still be
seen to the rear of the present White
Horse. This building was designed
in the late Victorian/Edwardian
style, after the original structure was
destroyed by fire in 1892.

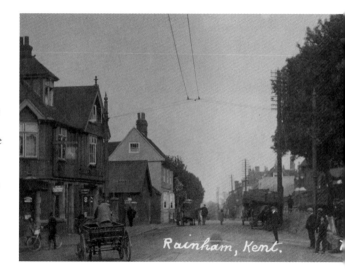

Cricketers Pub – Rainham
High Street
Whether as a coaching inn, a tram
terminus, or simply a meeting place
for local people, the Cricketers has
always been at the centre of village
life. Lying adjacent to St Margaret's
church, this pub has existed since
at least the eighteenth century. Its
Georgian incarnation, seen here, lasted
until 1938, when the present building
replaced it. The new Cricketers was
built behind the old one. Then the
Georgian Cricketers was demolished,
the vacant plot being turned into a
car park.

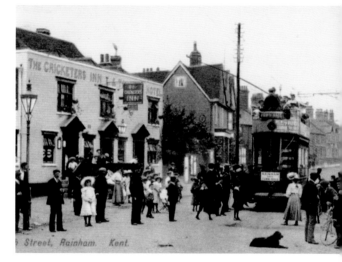

St Margaret's Parish Church, Rainham
This church is dedicated to St Margaret
of Antioch. The Anglo-Norman building
is on the old Roman Watling Street, and
is constructed of flint with limestone
dressings. Its most imposing feature is
the beacon tower. This formed part of
an early warning system connecting
the coast with London, which could be
activated in time of invasion. Internally,
there are statues and memorials to
locally important families, such as the
Bloors and particualrly the Tuftons,
who provided the Earls of Thanet.

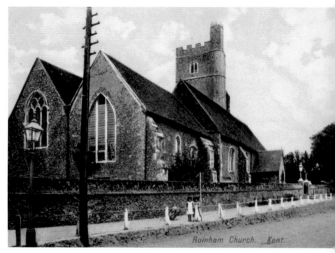

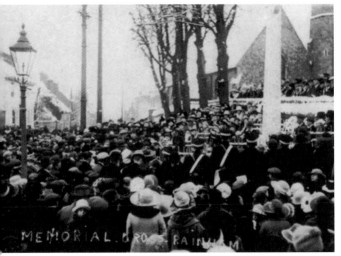

Rainham War Memorial
Snow had been falling when this memorial was unveiled on Sunday, 12 December 1920. It was constructed of Cornish granite and was 19 feet high. The structure was of an unusual design, taking the form of an Ionian cross. The memorial's base contains tablets inscribed with the names of ninety-nine men from the parish, who had been killed in the First World War.

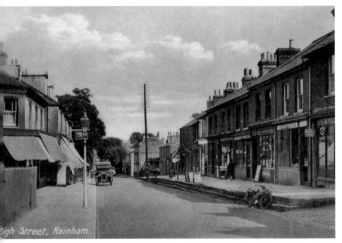

Rainham High Street
This 1930s view shows a Lyons Tea van making a delivery to a shop on the left. On the right we can see William Pilcher's, fruiterers, and the premises of Charles Kitchingham, butcher. Beyond them are the businesses of Hilda Bransbury, confectioner; Henry Abnett, bootmaker; Albert Grayson, newsagent; Lorna Oldland, florist; and Ernest Driver, wireless dealer.

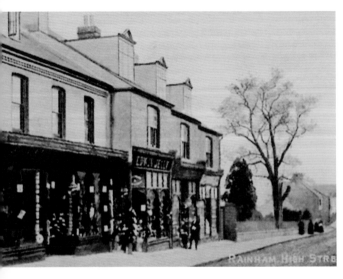

Rainham High Street
This photograph was taken from a spot a little further eastward from the previous picture. It is dominated by the premises of Edwin Jelly, a male outfitter. Jelly was also a partner in an estate agents business Harvey & Jelly. Marshall and Edwin Roads bear the forenames of Harvey & Jelly respectively.

Ivy Street, Rainham
This narrow Victorian street runs from Rainham High Street northwards. Most of its original residents would have been agricultural labourers or in trades associated with the River Medway. Methodism was strongly supported among the working class. In 1867, the United Methodist Free Church purchased a plot in Ivy Street and built a small chapel which may just be seen on the right. It closed in 1953, its congregation merging with that of the Station Road church.

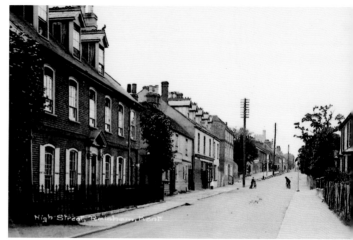

The Chestnuts
This large house, seen on the left, was the home of Thomas Wakeley, brick merchant and farmer. The house was set in half an acre of land extending to Chapel Lane. There were stables as well as flower and kitchen gardens. It contained ten bed and dressing rooms, dining and drawing rooms and a library. After the death of Wakeley's widow in 1900, the house was placed on the market. Other members of the Wakeley family purchased it for 1,000 guineas.

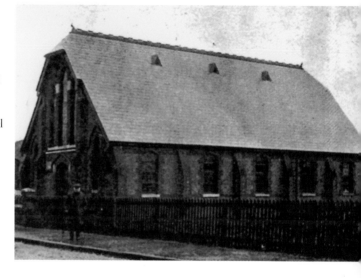

Rainham Congregational Church
Constructed on the corner of Broad Walk and High Dewar Road, this building superseded an earlier chapel of 1848. The latter, in Chapel Lane, became a Sunday school when its replacement opened in 1892. George Bond designed the new building, which was of yellow brick with red-brick and bath stone dressings. Some contemporary observers believed it was unnecessarily large for the village. It is now a children's nursery.

Rainham Pottery

This was an offshoot of the Upchurch pottery and was situated on the Dover Road, east of Rainham village. The premises consisted of a converted house and a mock-Tudor shop and café. The business specialised in domestic items, such as coffee sets, commemorative ware, etc. In 1955, the firm patented the colour 'Rainham Blue', which was used on most items. Once the M2 motorway bypassed Rainham, passing trade declined. By then there was also competition from cheaper mass-produced pottery. The business closed in 1975.

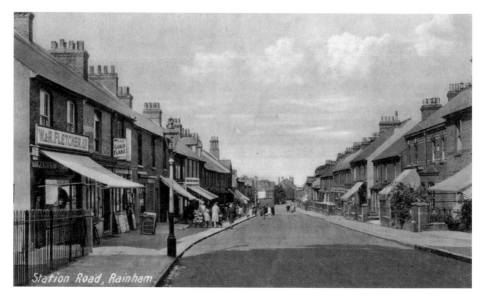

Station Road, Rainham

This was originally a track linking the Roman Watling Street with the even older Lower Rainham Road. By the early nineteenth century, the track was called White Horse Lane after the inn which stood at its summit. It was renamed Station Road after Rainham railway station opened in 1858. In this 1920s view we may see the premises of W. & R. Fletcher, butchers; Alf Calloway, pork butcher; and Fred Kitney, newsagent.

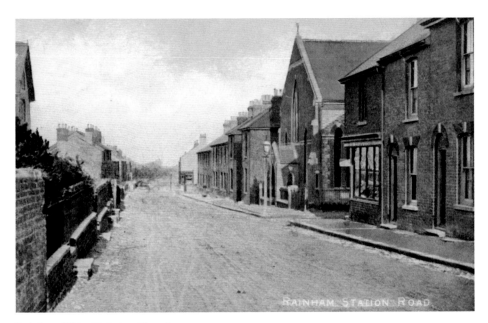

Rainham Bible Christian Church

This Methodist sect was present in Lower Rainham from the 1820s. As the village grew, the existing chapel became inadequate. A site at the corner of Station and Wakeley Roads was purchased, and Kemp Brothers of Rainham commenced the construction in 1899. The school room for 200 pupils opened in June 1900, and the church itself in August. The latter accommodated 225 worshippers. Today, the building still serves as a place of worship for Rainham Methodists.

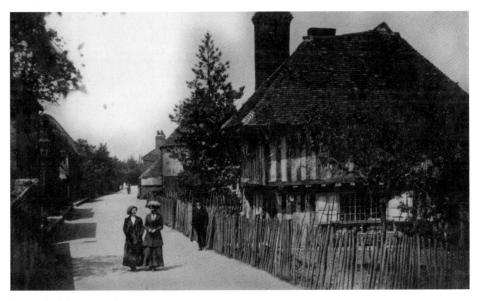

Lower Rainham Road

Lower Rainham remains a distinct community, although its shops, chapels and most of its pubs have disappeared. This row of late fifteenth-century timber-framed buildings is still an attractive landmark. However, these Edwardian ladies would be taking their lives in their hands if they dared to stroll in the middle of the road today.

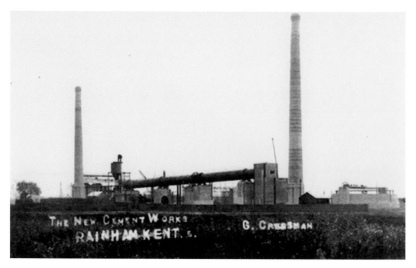

Cement Works, Motney Hill

Lower Rainham had abundant supplies of chalk and mud – the raw materials for cement making. This factory belonged to Goldsmiths, Essex barge owners, who quarried chalk from the corner of Lower Rainham Road and Berengrave Lane from 1901. A narrow gauge railway linked the chalk pit to the company's barges on the river. Shortly before the First World War, the firm opened the British Standard Cement Works to manufacture its own cement. The British Portland Cement Co. acquired the factory in 1930, but then closed it. Chalk quarrying also ceased by 1939.

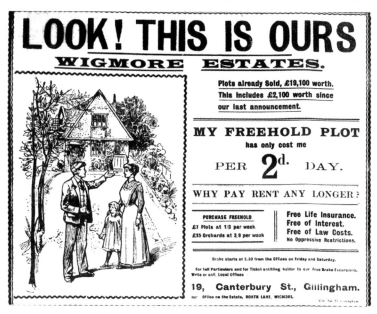

Advertisement for Plots in Wigmore

When the 365-acre 'Wigmore' agricultural estate came onto the market in 1902, it was purchased by British Garden Cities Ltd. Roads were built, plots laid out and in 1906 marketing began. The prices of the plots advertised here were prohibitive for most working-class people. As the local newspaper said: 'This Eldorado, therefore is within the means of only the most thrifty of workmen, and thereby you have the nucleus of a steady, sober community.'

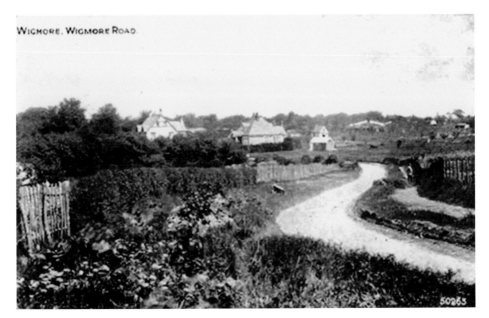

Wigmore Road
Wigmore developed slowly. Many Medway families purchased plots, on which they built shanties as weekend retreats. It took many years for these shacks to give way to brick-built houses in well planned streets, and for the many smallholdings and pig farms to disappear under tarmac and neat gardens. Significantly, one of the major Wigmore social venues still bears the name 'Smallholders Club'.

Wigmore Post Office, Woodside
Wigmore, including Woodside, began to evolve before the First World War. The first reference to these premises as a post office appears in a street directory of 1928, although the shop had existed for some years before. In the 1920s, it was kept by George Munn. His former residence, Duncan Lodge, has survived as a shop to this day.

Springvale, Wigmore

Wigmore developed piecemeal as plots of the former farming estate were sold off to individuals and developers. Springvale evolved from the late 1920s, linking Woodside with York Road (later renamed Durham Road). At first, its houses and bungalows were unnumbered and known only by name – Chez Nous, Dun Roamin and The Bungalow among them. As the number of residences grew from the mid-1930s, they were given numbers.

Birth of Alexandra Hospital

By 1900, Gillingham's existing infectious diseases hospital in Canterbury Street had become inadequate. It was surrounded by housing, and a municipal park was planned for an adjacent site. A more appropriate location was sought outside the town itself. A temporary solution at Hempstead failed; the council then accepted a gift of land at Wigmore from Richard Batchelor, a farmer and brick maker.

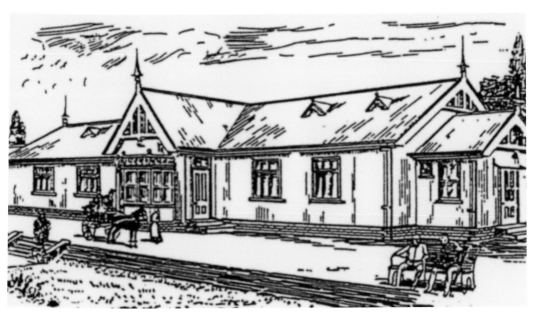

Opening of Alexandra Hospital
A twelve-bed prefabricated building was purchased from the London firm of Humphreys Isolation Hospitals. This was then constructed on the newly acquired site, and opened in January 1902. However, with incidences of smallpox in decline, the building was only used sporadically.

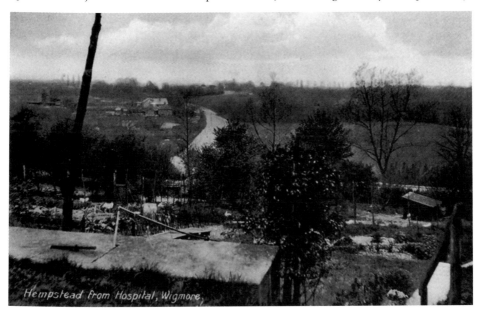

Hospital with a View
As can be appreciated from this photograph, the rural location of the new hospital was ideal – infectious cases could be treated well away from the bustling town of Gillingham. The woods and farmland have since disappeared, and the area around Hempstead has been covered with housing. However, the boundary wall of the former hospital may still be seen near the Hempstead Road–Hoath Way junction.

Lidsing Chapel, 1820

There was probably a chapel at Lidsing in Saxon times, but no evidence has been found of a village there. The later flint chapel served people from scattered farmsteads, and those from the parish of Boxley unwilling to descend the hill to their village church. From the mid-sixteenth century, Lidsing was a chapel of ease attached to Gillingham parish.

Lidsing Chapel Demolition

By the early nineteenth century, the isolated Lidsing chapel was neglected and vandalised. In 1880, the *Chatham News* commented that visitors 'have seen the broken down pulpit, the mouldering pews and forms out of shape and order, covered with dust and wood and broken tiles from the tottering roof'. The church authorities demolished the chapel in 1883. The site of this former place of worship may be found in woods opposite the Hempstead Valley shopping centre.